CALLIGRAPHY STYLING

VERONICA HALIM

CALLIGRAPHY STYLING

LEARN THE ART OF BEAUTIFUL WRITING

LARK
New York

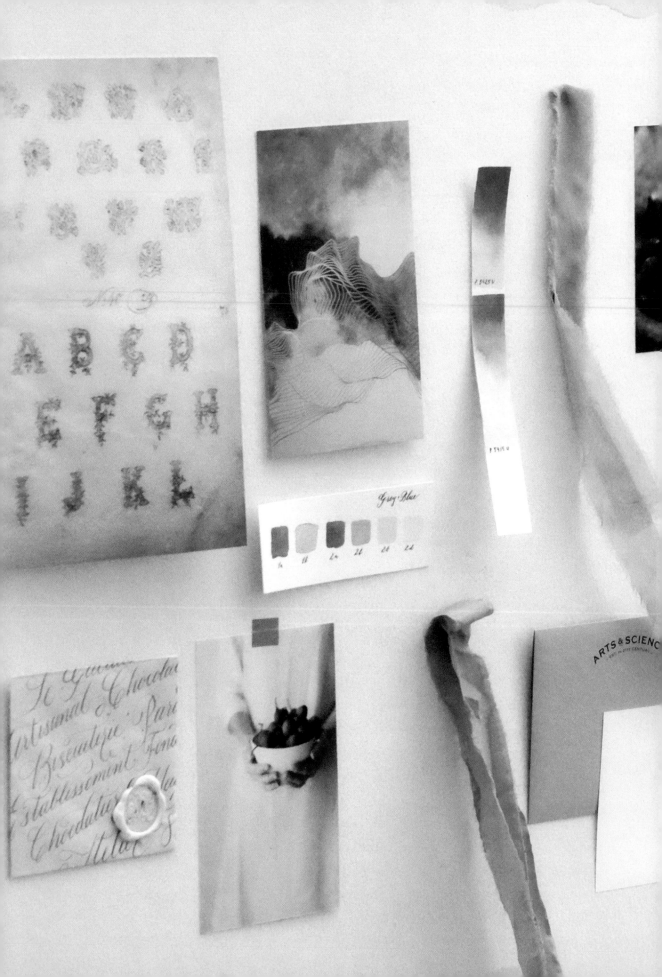

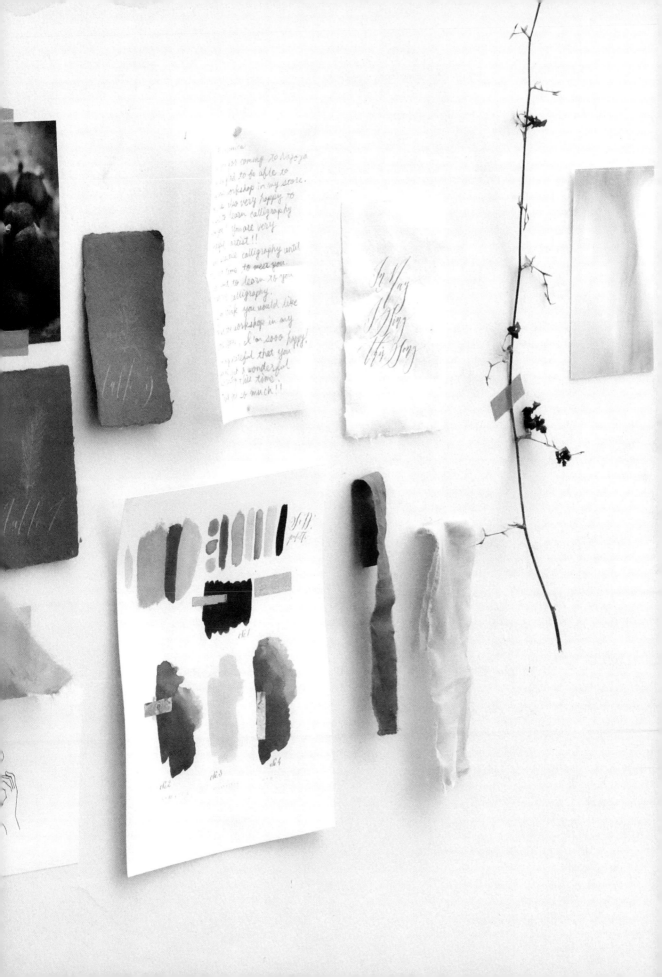

CONTENTS

Chapter 5

Wrappings, Papers, and Packaging

Chapter 6

The World of Weddings

Chapter 7

Small Gatherings and Entertaining

The icons in this book indicate the
materials I've used for each project.

🖊 Nib

🖊 Ink (or marker, paint, pigment, etc.)

📄 Paper (or other writing surfaces)

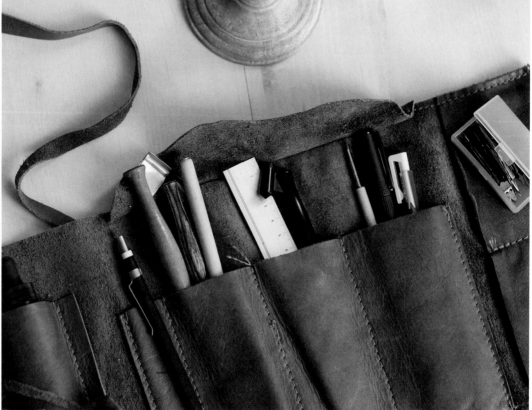

My first encounter with calligraphy came when I was studying graphic design at an Australian university. One semester, I enrolled in a typography class, which briefly touched upon calligraphy. The handwritten lettering recalled an analog era when no two works were exactly the same. After graduating college, I found work as a graphic designer in Shanghai and Jakarta and eventually became a creative director for corporate clients. It was now the dawn of the digital age. In 2009, I co-founded my own design company. As my days got busier—and ever more digital—my stress began to build. Then I happened to remember the calligraphy I'd briefly studied in college, and I took a pen back into my hand.

Unlike letters typed into a computer by keyboard, ink once written on paper cannot be erased. Writing in ink requires a focus of intent and concentration on the task at hand. The sensation is akin to meditation. The beautiful lines and shapes created through the pen are all unique, and they share much commonality with nature, evoking the gentle interlacing of tree branches and wavering blades of grass. When I immerse my thoughts in calligraphy, a calmness settles over me, like I'm in the middle of a forest, and that calm becomes inspiration, flowing through my fingers. The first time I experienced this feeling was an awakening—a moment of profound bliss.

From that moment, I dove into the world of calligraphy, taking lessons, participating in workshops, and practicing day after day. Gradually, the writing became natural to me, and I realized I could connect calligraphy with my other skills and interests—design as well as arts and crafts—to create so many things. In this book, I'll offer many ideas for putting calligraphy to good use for items including cards and gift-wrapping, and for occasions ranging from weddings to small gatherings. My goal is to enable you to use calligraphy not just as art but as a part of your everyday life.

CHAPTER

1

———

Materials And Basic Lessons

When the flowing beauty of calligraphy first captured me, I began with modern script. Unrestrained by formal rules, the freeform style was easy to get accustomed to. But after a little time, I wanted to gain a better grasp of the fundamentals, and I started practicing Copperplate script, a traditional style with fixed rules.

Calligraphy contains a wide range of writing styles, which can be divided into three broad categories: pointed pen calligraphy, broad pen calligraphy, and brush calligraphy. The two styles I present in this book—Modern and Classic Copperplate— are pointed pen scripts.

For beginners, the first step is to learn how to use the writing materials. In the following pages I suggest my favorite basic nibs, holders, inks, papers, and other materials, which I use in my projects throughout the book. The best way to find your own preferred tools is to experiment with different ones. Calligraphy improves only through practice, but you should go at your own pace. Stay relaxed, and have fun!

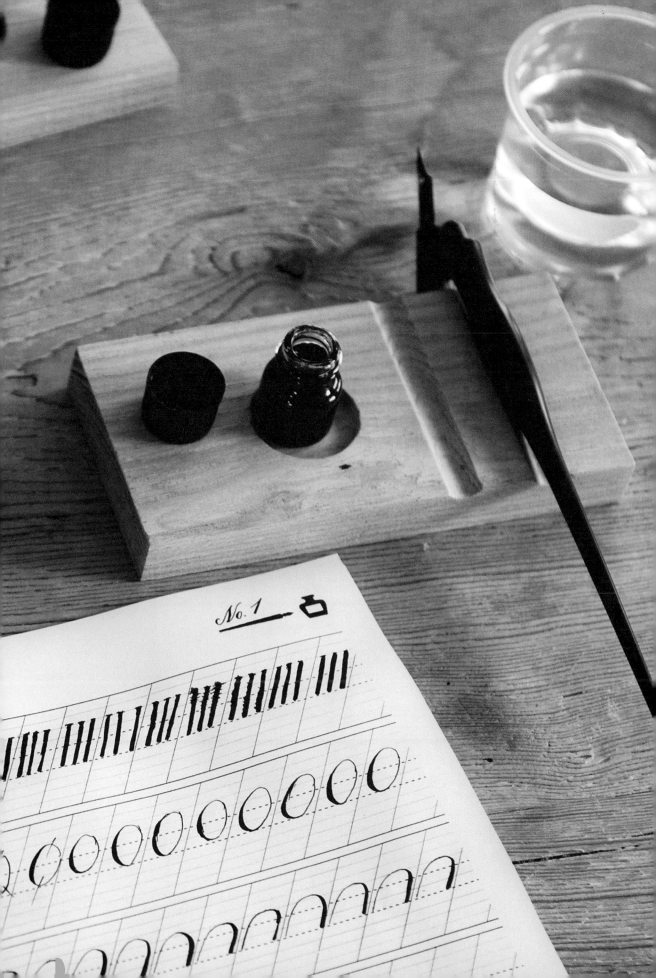

NIB & PEN HOLDER

Nibs come in different sizes, spreads, and ranges of flexibility. By trying a variety, you can find the ones that best suit you. Pen holders are divided into two main styles: straight and oblique. The angled tip of oblique holders produces a natural slant when writing, while straight holders require a more conscious effort. Oblique holders are used for pointed pen calligraphy only, while straight holders can be used for both.

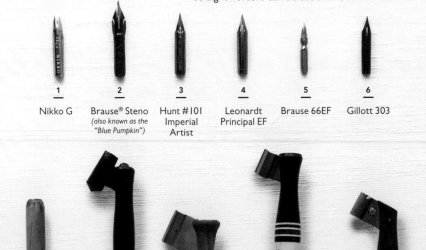

1	2	3	4	5	6
Nikko G	Brause® Steno *(also known as the "Blue Pumpkin")*	Hunt #101 Imperial Artist	Leonardt Principal EF	Brause 66EF	Gillott 303

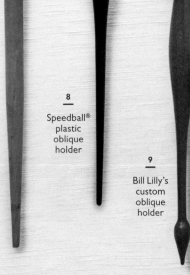

7
Wooden straight holder

8
Speedball® plastic oblique holder

9
Bill Lilly's custom oblique holder

10
Brian Smith's custom oblique holder

11
Hourglass adjustable oblique holder

1. Made in Japan. Also used for drawing manga. Long lasting, easy to use, and possessing moderate flexibility, this nib is a great choice for beginners. **2.** Made in Germany. A more flexible nib capable of drawing beautiful and fine strokes, while also being durable. **3.** Made in the US. A high-flex nib capable of freely drawing both fine and thick strokes. Recommended for flourishes. **4.** Made in England. Its very fine tip can draw beautiful strokes but requires a greater degree of pressure control. **5.** Made in Germany. High-flex with a fine tip, this nib can freely write thick strokes and is also suitable for fine detail work. Tends not to catch on paper fibers, making it well-suited for use on textured paper. **6.** Made in England. Fairly flexible and on the smaller size, this nib is capable of fine detail work and is recommended when writing smaller lettering. Caution is required when used on textured handmade paper, as it has a tendency to catch on raised paper fibers. **7.** A straight holder made of natural wood. It can be used with both pointed and broad-tip nibs. **8.** I use this plastic oblique holder in my workshops, and it can fit a wide variety of nibs. **9.** Made by Master Penman Bill Lilly, this holder is ideal for Hunt 101 and Leonardt EF Principal nibs. **10.** An oblique holder made in the style of an antique Magnusson holder. The grip is made of ebony. Ideal for the Leonardt EF Principal nib. **11.** An oblique holder with an adjustable flange to fit multiple nib sizes.

About Nibs

TIP

SLIT

VENT HOLE

This provides a place for ink to pool while writing. When dipping your pen in ink, be sure to allow ink to fill this space.

The nib is split into two parts. The slit widens under pressure, allowing lines to vary in thickness.

Using a Nib for the First Time

New nibs come with a protective coating that may repel ink and cause poor ink flow. When using a nib for the first time, you should wipe it several times with alcohol swabs, or a cloth or paper towel dampened with rubbing alcohol.

WHEN TO REPLACE A NIB

When the tip of your nib begins to frequently catch on paper, or when the nib no longer writes smoothly, replace it with a new one.

Attaching the Nib

Slide the nib into the ring at the end of the holder.

Twist the nib so that its upper side is aligned with that of the holder, then push in the nib until it is secure.

The top of the nib is aligned with the holder.

The nib is oriented sideways.

Dipping into the Ink

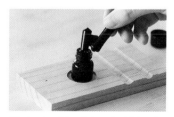

Dip the tip of the nib into the ink bottle.

Check to make sure that ink has pooled in the vent hole.

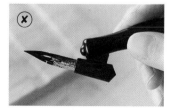

Ink has not entered the vent hole.

Cleaning Up

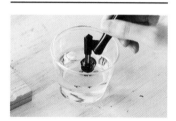

Rinse the nib thoroughly in water.

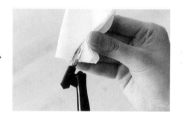

Wipe the nib dry with alcohol swabs, or a cloth or paper towel dampened with rubbing alcohol.

Remove the nib from its holder and store it so that its tip never presses against a hard surface.

Materials 2

INK

Calligraphy can be written with more than just black ink. Inks come in a wide variety of colors, including vibrant hues and metallics. I prefer water-based inks when given the choice. Water-based inks tend not to clog the nib and are easy to clean, meaning your nibs will last longer. Another important factor affecting the quality of the finished writing is the ink's consistency, or thickness. Thinner inks will make for finer strokes, and thicker ink for thicker strokes.

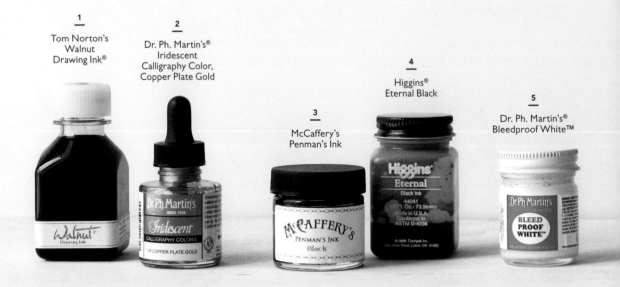

1
Tom Norton's
Walnut
Drawing Ink®

2
Dr. Ph. Martin's®
Iridescent
Calligraphy Color,
Copper Plate Gold

3
McCaffery's
Penman's Ink

4
Higgins®
Eternal Black

5
Dr. Ph. Martin's®
Bleedproof White™

1. This ink can produce beautifully fine sepia-colored strokes. **2.** Made in the US. A Copperplate gold metallic ink that contains a beautiful mix of hues. **3.** Made in the US. This is an iron gall ink, made using iron salts and vegetable tannic acids, and is capable of writing incredibly fine strokes. Iron gall inks were used on manuscripts dating back to the Middle Ages. **4.** Made in the US. Capable of fine strokes and easy to use, this ink is superior for practicing, and I use it for my workshops. **5.** Made in the US. An opaque white ink. Dilute with water until the ink is the consistency of milk.

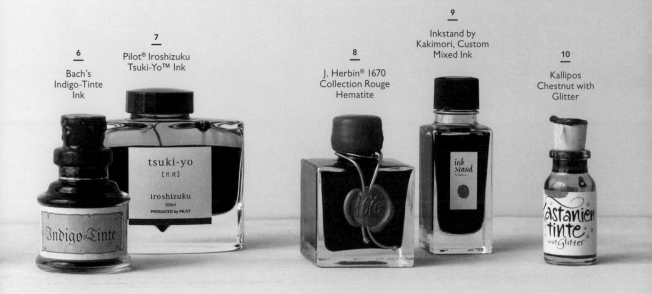

6
Bach's
Indigo-Tinte
Ink

7
Pilot® Iroshizuku
Tsuki-Yo™ Ink

8
J. Herbin® 1670
Collection Rouge
Hematite

9
Inkstand by
Kakimori, Custom
Mixed Ink

10
Kallipos
Chestnut with
Glitter

6. An indigo iron gall ink from Germany. I love the vintage-style bottle. **7.** Fountain pen ink from Japan with a strikingly complex color. Can also be used for calligraphy. **8.** Created in celebration of the J. Herbin Company's 340th anniversary. Dark red with a gold sheen. **9.** Custom-made ink from "inkstand by kakimori" in Tokyo's Kuramae district. Can also be used as fountain pen ink. **10.** Homemade ink from Germany with a charmingly beautiful metallic color.

OTHER MATERIALS

Art supplies, pigments, paints, and mediums are your trusty companions that will expand the possibilities of your calligraphy. Markers will allow you to write on glass or cloth, and by mixing paints, you can make your own custom ink. Metallic inks and gold foil are irreplaceable mainstays when you want to create something that feels special.

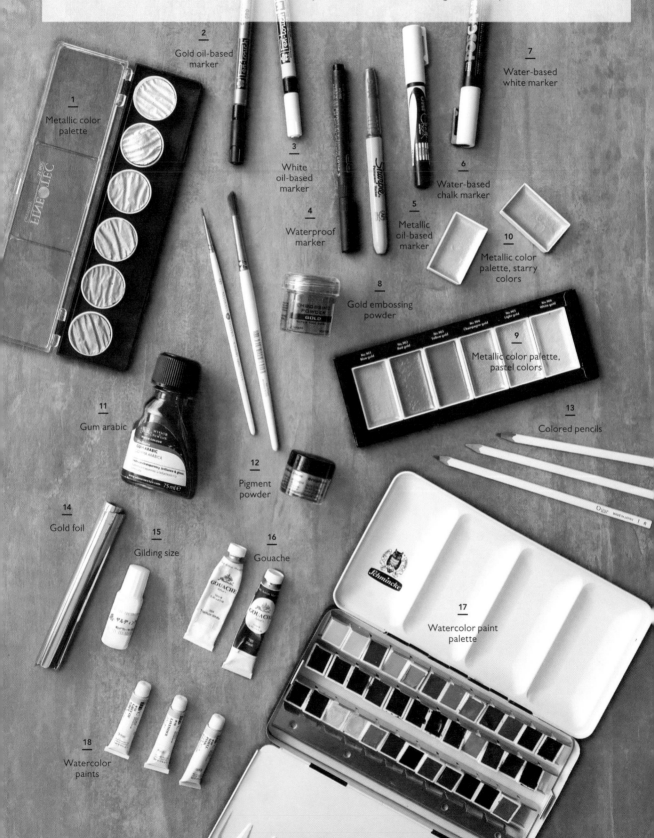

1 Metallic color palette

2 Gold oil-based marker

3 White oil-based marker

4 Waterproof marker

5 Metallic oil-based marker

6 Water-based chalk marker

7 Water-based white marker

8 Gold embossing powder

9 Metallic color palette, pastel colors

10 Metallic color palette, starry colors

11 Gum arabic

12 Pigment powder

13 Colored pencils

14 Gold foil

15 Gilding size

16 Gouache

17 Watercolor paint palette

18 Watercolor paints

Using Watercolor and Gouache

Watercolor paints have a finish with a translucent feel, while gouache is opaque with greater definition. Choose the one that best fits your image.

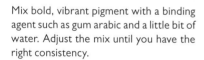

Watercolor paint

Gouache

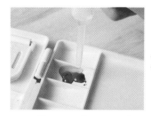

1 Place a small amount of paint into the palette and add water using a dropper.

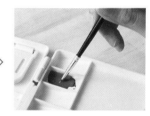

2 Mix with a paintbrush.

3 Load the paint onto your brush and coat the front and back of your nib.

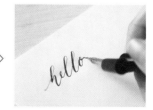

4 The nib should write smoothly. Gradually add water until you find a consistency that works.

Using Metallic Pigment

Mix bold, vibrant pigment with a binding agent such as gum arabic and a little bit of water. Adjust the mix until you have the right consistency.

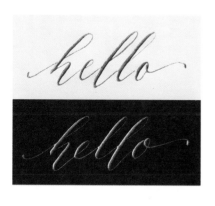

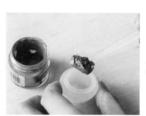

1 Using a small spoon or scoop, place pigment into a mixing container.

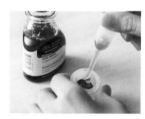

2 Using a dropper, add gum arabic until you have a 2:1 ratio of pigment to gum arabic.

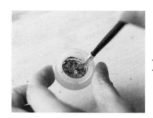

3 Mix with a paintbrush.

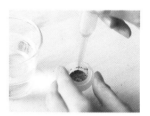

4 Add several drops of water with a dropper.

1. A high-quality metallic color palette. **2–3.** Opaque oil-based gold and white markers. **4.** Everyday waterproof marker. **5.** Fast-drying oil-based metallic marker. **6.** Water-based chalk marker. **7.** A water-based white marker that is water-resistant once dry. **8.** Gold embossing powder. Also used in crafting and scrapbooking. **9–10.** As with 1, additional metallic color palettes. Made in Japan. **11.** Gum arabic. A transparent binding agent that can be added to paint, ink, or pigment. Can also be used to reduce ink bleeding. **12.** Powdered metallic pigment. **13.** Colored pencil set. **14.** Artificial gold foil. Thicker than gold leaf and easier to use. **15.** Paste designed for use with gold leaf. **16.** Opaque watercolor paint. **17.** Watercolor paints in a travel case. **18.** Watercolor paints. As with 17, produces a more translucent finish.

PAPER

The choice of paper is just as important as the drawing implements. Try to select high-quality paper that has a smooth surface. Lighter, cheaper paper can cause ink to bleed and can have unwanted feathering. When possible, it's best to test out paper before you buy it.

Smooth Copy Paper

For practice or in lessons, I use copy paper with 20 lb./70–75 gsm* paper weight. It accepts ink well and does not bleed. You can also place a guide sheet beneath it and, with the aid of some light, use the guidelines printed on the sheet for your projects.

Watercolor Paper

Watercolor paper holds up to water well—I recommend using it when you want to pair your calligraphy with watercolor or gouache illustrations. When painted, it won't curl up or ripple.

Sketch and Drawing Paper

This type of paper takes ink well. It comes in many differing thicknesses—choose a thickness that suits your project. Sketch and drawing paper is also suitable for watercolor paint or gouache as well as embossing.

Cotton Paper

Made from cotton, this paper is tough and resilient while still being cushion-soft. Cotton paper is an excellent choice when your project includes letterpress printing or debossing.

Fine Italian Paper

Fine Italian paper looks great after going through a printer or letterpress, making it a frequent choice for wedding invitations.

Handmade Paper

Each sheet of handmade paper has a unique surface, lending a feeling of something truly special to your project. However, it tends not to hold ink very well and can snag finer-tipped nibs. The rough, irregular edges of a deckle-edge paper can also add delightful character.

Kraft Paper

The brown color on both sides of kraft paper lends a more natural feel to cards and packaging. Some varieties can take on ink far better than others—stick with paper that has a smooth surface and high density.

Tracing Paper

Tracing paper can be layered for an enchanting transparent effect. Watery inks don't do well here. Instead, use thicker inks that allow you to regulate their density by adding water only when absolutely needed. Gouache and Dr. Ph. Martin's Bleedproof White also work well.

Onionskin

Onionskin is thin and smooth. It is partially transparent like glassine paper (a smooth, glossy, translucent water-resistant paper) but not as glossy. When writing on this type of paper, use a light touch.

* gsm is short for "grams per square meter" and refers to the weight of paper per square meter of surface area. In the US, weight is expressed in pounds. 20 lb. bond copy paper is equal to 70 gsm copy paper.

{ Basic Lesson 1 }

HOLDING THE PEN

Holding the pen correctly is the first step toward writing beautiful calligraphy. The three key factors to consider are the slant, angle, and pressure that you're using with the pen. When practicing, use a guide sheet with slanted guidelines.

SLANT

When holding your pen, the tip of the nib should point at a right-facing angle and align with the slanted guidelines. You should move your pen using your arm and not your wrist.

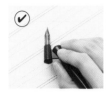 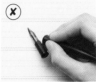 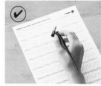 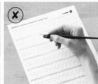

You can rotate the paper if it makes writing easier.

The pen's nib is facing left instead of right.

Remember to move the pen with your arm.

The pen is being moved by the writer's wrist.

ANGLE

The pen should not be held too upright or too low. You should be making a 40–55° angle off the paper's surface.

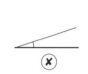

Try to maintain something near a 40–55° angle.

PRESSURE

Downstrokes are typically written with additional pressure to make a thicker stroke. Upstrokes are written with a lighter touch for a thin stroke.

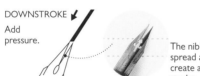

DOWNSTROKE
Add pressure.

The nib's tines spread apart to create a thick stroke.

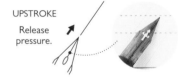

UPSTROKE
Release pressure.

{ Basic Lesson 2 }

BASIC STROKES

The letters of the alphabet are almost entirely composed of a combination of simple strokes. Practicing these fundawwriting calligraphy, you should still repeat these as warm-up exercises.

1 Downstroke

When beginning this stroke, slide your pen slightly to the right to create well-defined corners, making a flat square edge at the top of the stroke. When moving the pen down, maintain constant pressure so that the line remains a uniform width.

 >

2 Upstroke

With light pressure, move from the bottom of the stroke up the paper. The tip should feel as if it is sliding across the paper's surface.

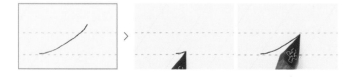

3 Release and Press
Stroke *(Overturn Stroke)*

The thin upstroke and thick downstroke should be parallel. Be careful not to let the transition between the strokes become pointed—keep the curve rounded and smooth.

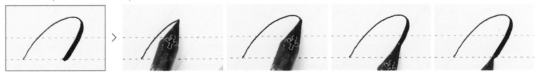

4 Press and Release
Stroke *(Underturn Stroke)*

As with the overturn stroke, keep the upstroke and downstroke parallel. Be careful not to let the transition become pointed—keep the curve rounded and smooth.

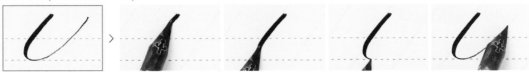

5 Combination
Stroke

Keep the transitions smooth and the spacing between the strokes even.

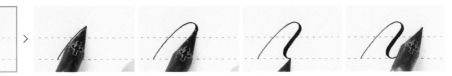

6 Oval

Form an almond-shaped oval. Slowly increase the pressure when beginning the downstroke.

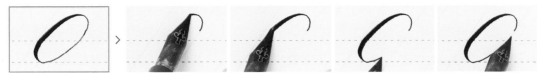

7 Compound
Curve

Begin without pressure and slowly press harder as the line straightens. The beginning and end of the stroke should be slightly curved.

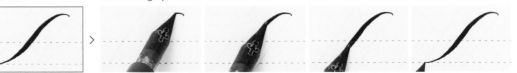

8 Horizontal-Eight
Stroke

Create this stroke by writing horizontal number eights. Don't shortchange the length of the first curve, and keep the left and right loops the same size.

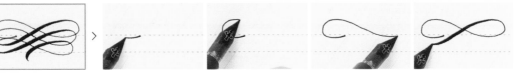

9 Spiral Stroke

Begin with an upstroke, then add pressure for the downstroke. Make the ovals smaller as you go.

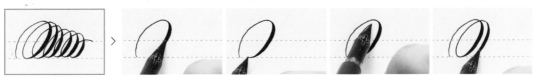

ALPHABETS
Classic Style

This style is based on the Roundhand and Classic Copperplate styles popularized by English writers in the sixteenth century. The rounded shapes and elegant feel give this alphabet its appeal.

Lowercase

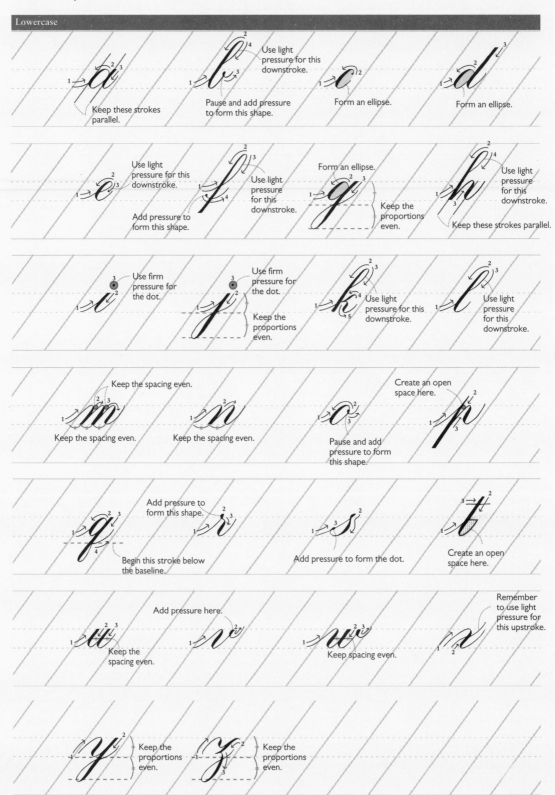

Keep these strokes parallel.

Use light pressure for this downstroke.

Pause and add pressure to form this shape.

Form an ellipse.

Form an ellipse.

Use light pressure for this downstroke.

Add pressure to form this shape.

Use light pressure for this downstroke.

Form an ellipse.

Keep the proportions even.

Use light pressure for this downstroke.

Keep these strokes parallel.

Use firm pressure for the dot.

Use firm pressure for the dot.

Keep the proportions even.

Use light pressure for this downstroke.

Use light pressure for this downstroke.

Keep the spacing even.

Keep the spacing even.

Keep the spacing even.

Keep the spacing even.

Pause and add pressure to form this shape.

Create an open space here.

Add pressure to form this shape.

Begin this stroke below the baseline.

Add pressure to form the dot.

Create an open space here.

Add pressure here.

Keep the spacing even.

Keep spacing even.

Remember to use light pressure for this upstroke.

Keep the proportions even.

Keep the proportions even.

There are many different calligraphic scripts. In this book, I introduce two styles that I use frequently: Classic Copperplate and Modern. A printable practice guide sheet is available for download at: veronicahalim.com/resources.

Uppercase

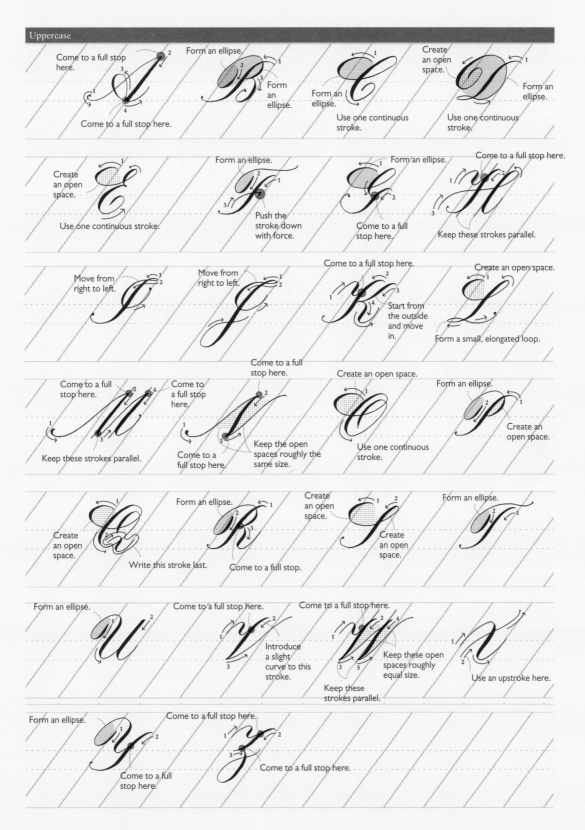

Modern Style

This Modern style is more freeform, allowing for more individuality. Its stylish feel makes it popular for weddings.

Lowercase

You may continue without stopping after the first stroke.

Create an open space.

Pause the stroke and add pressure to form this shape.

Form an ellipse.

Create an open space.

Extend the letter below the baseline.

Create an open space.

Use one continuous stroke.

Stop here before beginning the next stroke.

You may close this loop or leave it open.

Extend the letter below the baseline.

Use firm pressure for the dot.

Use firm pressure for the dot.

Create an open space.

Extend the letter below the baseline.

Create an open space.

Use one continuous stroke.

Create an open space.

Extend the letter below the baseline.

Extend the letter below the baseline.

Use one continuous stroke.

Use one continuous stroke.

Create an open space.

Gently curve the crossbar.

Add pressure.

Create a loop.

Release pressure.

Add pressure.

Use one continuous stroke.

Come to a full stop here.

Use one continuous stroke, or stop here and begin a second stroke.

Use an upward stroke.

Extend the letter below the baseline.

Extend the letter below the baseline.

Create an open space.

Create an open space.

Uppercase

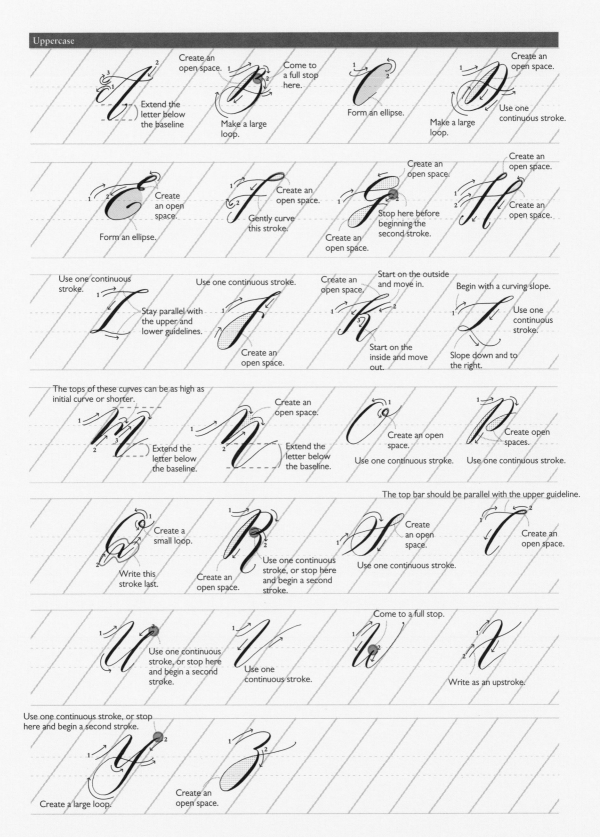

Extend the letter below the baseline

Create an open space.

Come to a full stop here.

Make a large loop.

Form an ellipse.

Create an open space.

Make a large loop.

Use one continuous stroke.

Form an ellipse.

Create an open space.

Create an open space.

Gently curve this stroke.

Create an open space.

Create an open space.

Stop here before beginning the second stroke.

Create an open space.

Create an open space.

Use one continuous stroke.

Stay parallel with the upper and lower guidelines.

Use one continuous stroke.

Create an open space.

Create an open space.

Start on the outside and move in.

Start on the inside and move out.

Begin with a curving slope.

Use one continuous stroke.

Slope down and to the right.

The tops of these curves can be as high as initial curve or shorter.

Extend the letter below the baseline.

Extend the letter below the baseline.

Create an open space.

Create an open space.

Use one continuous stroke.

Create open spaces.

Use one continuous stroke.

The top bar should be parallel with the upper guideline.

Create a small loop.

Write this stroke last.

Create an open space.

Use one continuous stroke, or stop here and begin a second stroke.

Create an open space.

Use one continuous stroke.

Create an open space.

Use one continuous stroke, or stop here and begin a second stroke.

Come to a full stop.

Use one continuous stroke.

Write as an upstroke.

Use one continuous stroke, or stop here and begin a second stroke.

Create a large loop.

Create an open space.

27

Flourish

Because of its looping decorative flourishes, this style of script is primarily used with uppercase letters. There are many variations—please treat this example only as an introduction.

Classic Copperplate

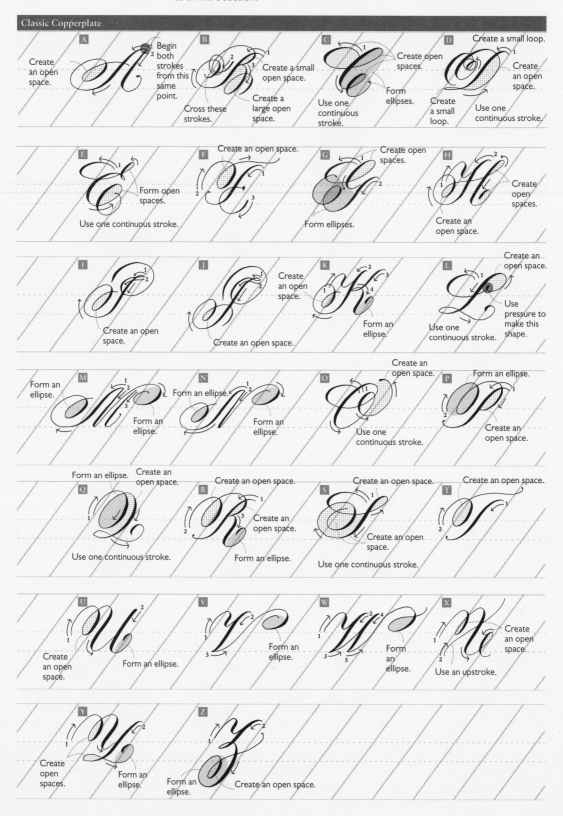

Modern

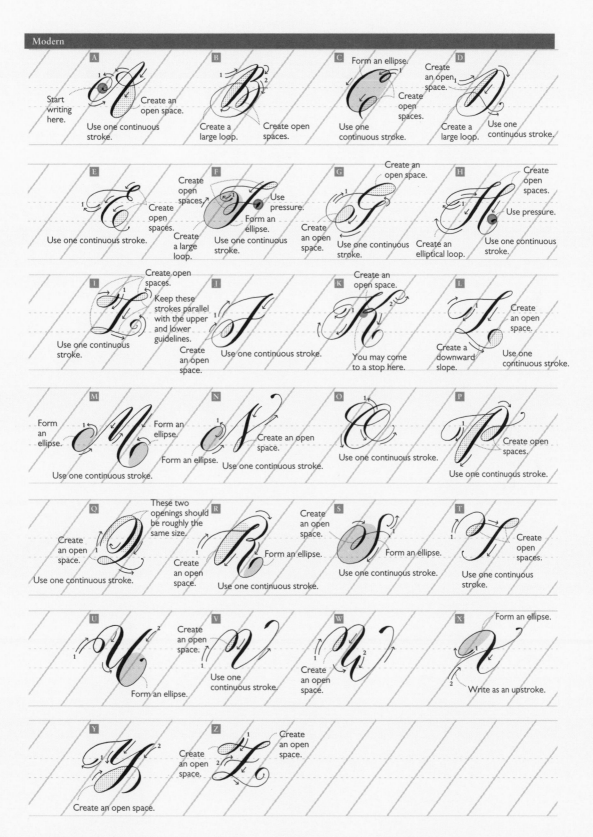

Numbers

Numbers are used in many occasions, like addressing mail and writing table numbers for weddings. Practice them along with the alphabet.

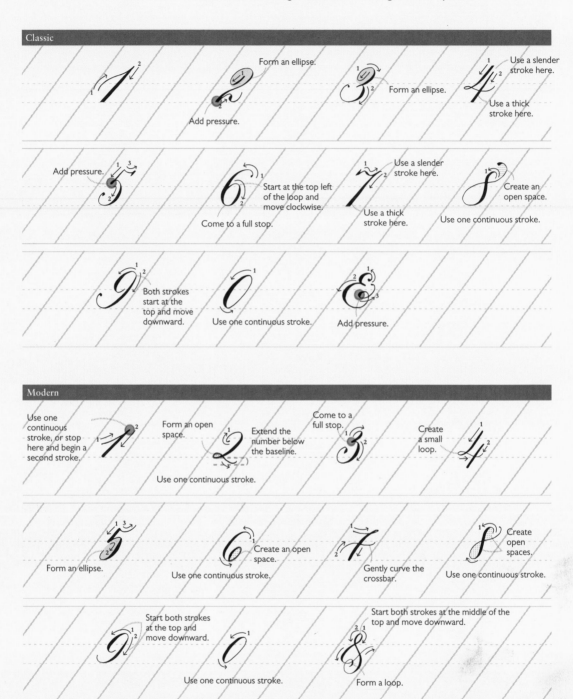

Classic

1

2 — Form an ellipse. / Add pressure.

3 — Form an ellipse.

4 — Use a slender stroke here. / Use a thick stroke here.

5 — Add pressure.

6 — Start at the top left of the loop and move clockwise. / Come to a full stop.

7 — Use a slender stroke here. / Use a thick stroke here.

8 — Create an open space. / Use one continuous stroke.

9 — Both strokes start at the top and move downward.

0 — Use one continuous stroke.

& — Add pressure.

Modern

1 — Use one continuous stroke, or stop here and begin a second stroke.

2 — Form an open space. / Extend the number below the baseline. / Use one continuous stroke.

3 — Come to a full stop.

4 — Create a small loop.

5 — Form an ellipse.

6 — Create an open space. / Use one continuous stroke.

7 — Gently curve the crossbar.

8 — Create open spaces. / Use one continuous stroke.

9 — Start both strokes at the top and move downward.

0 — Use one continuous stroke.

& — Start both strokes at the middle of the top and move downward. / Form a loop.

Basic Lesson 4

PRACTICE WORDS

The key to combining letters into words is in the consistency of your thick and thin strokes, the slant of your strokes, and the spacing between each letter.

Letter Connections

Letters are connected by upstrokes. When you finish a letter, take a moment to pause, and don't rush into the next letter.

Create an open space.

Form an ellipse.

an *bi* *eg* *rs* *st*

Continue from the *a*'s exit stroke.

Keep this rounded, and don't let it become a sharp point.

Attach the *t*'s entrance slope to the *s*.

Letter Spacing

Try to maintain even spacing among the elements of each letter. When I write, I pay close attention to any elliptical spaces. Following every letter, pause and take a moment to observe your spacing.

Keep these areas rounded.

minimum

Make the other openings match the size of this opening.

Form an ellipse.

from

Make the other openings match the size of this ellipse.

Form an ellipse

dear

Make the other openings match the size of this ellipse.

Uppercase and Lowercase Letter Connections

Uppercase letters that exit with an upstroke (such as *A*, *J*, and *M*) connect directly into the next letter. For uppercase letters that don't exit with an upstroke (such as *F*, *S*, *N*, and *D*), leave a small space before beginning the next letter.

January *February* *March*

Connect the *J*'s exit stroke with the *a*.

Don't force these letters to connect—leave a small space open.

Connect the *M*'s exit stroke with the *a*'s entrance stroke.

April *May* *June*

Connect the *A*'s exit stroke directly into the *p*'s entrance stroke.

Connect the *M*'s exit stroke with the *a*'s entrance stroke.

Connect the *J*'s exit stroke with the *u*'s entrance stroke.

Connect the *J*'s exit stroke with the *u*'s entrance stroke.

July *August* *September*

Connect the *A*'s exit stroke directly into the *u*'s entrance stroke.

Don't force these letters to connect—leave a small space open.

October *November* *December*

Don't force these letters to connect—leave a small space open.

Don't force these letters to connect—leave a small space open.

Don't force these letters to connect—leave a small space open.

31

Basic Lesson 5

WORDS AND PHRASES

C ···CLASSIC CF ···CLASSIC Flourish M ···MODERN MF ···MODERN Flourish

Thank You

C

Form an ellipse.

Form an ellipse.

Thank You

Make these ellipses roughly the same size.

CF

Form an ellipse.

You may cross these strokes.

Create a large curve.

Thank You

Create an open space.

Form an ellipse.

M

Elongate this stroke.

Make this stroke flowing and long.

Thank You

Create these strokes with visual rhythm.

You may cross these strokes.

MF

Thank You

You may cross these strokes.

Best Wishes

C

Form an ellipse.

Best Wishes

CF

Form an ellipse.

Create a large curve.

Best Wishes

You may cross these strokes.

M

Elongate the crossbar to cross into the W.

Make this stroke long and flowing.

Best Wishes

MF

Cross these strokes.

Best Wishes

I've selected several commonly used seasonal and celebratory phrases to illustrate the four script styles. Practice whichever style (or styles) you like.

Happy Birthday

C
Create an open space.
Make these ellipses roughly the same size.
Happy Birthday
Create an open space.

CF
Form an ellipse.
You may cross these strokes.
Create a large curve.
Happy Birthday
Create an open space.

M
Make this stroke long and flowing.
Create these strokes with visual rhythm.
Happy Birthday
Create these strokes with visual rhythm.

MF
Make this stroke long and flowing.
Create a large curve.
Happy Birthday
Create these strokes with visual rhythm.

Congratulations

C
Form an ellipse
Keep these curves rounded.
Keep these curves rounded.
Create an open space.
Congratulations
Make these ellipses roughly the same size.

CF
Congratulations
Make this stroke with a large curve.
Make these ellipses roughly the same size.

M
Make this stroke long, flowing, and dramatic.
Congratulations
You may cross these strokes.
Create these strokes with visual rhythm.

MF
Congratulations
You may cross these strokes.
Create these strokes with visual rhythm.

C ···CLASSIC CF ···CLASSIC Flourish M ···MODERN MF ···MODERN Flourish

Merry Christmas

C

Keep these curves rounded.

Merry Christmas

You may leave a space here.

CF

Form an ellipse.

Form an ellipse.

Merry Christmas

Form an ellipse.

Cross these strokes.

M

Make this stroke long and flowing.

Merry Christmas

Create these strokes with visual rhythm.

MF

Create a large curve.

Merry Christmas

Form an ellipse.

Noel

C

Noel

You may leave a space here.

CF

Form an ellipse.

Noel

Form an ellipse.

M

Noel

Create these strokes with visual rhythm.

MF

Noel

Cross these strokes.

Halloween

C

Create open spaces.

Halloween

CF

Halloween

Create a large curve.

M

Halloween

Create these strokes with visual rhythm.

MF

Halloween

Create an open space

Create these strokes with visual rhythm.

The Wedding

C

Create an ellipse.

You may leave a space here.

Make these ellipses roughly the same size.

You may leave a space here.

The Wedding

CF

Form an ellipse.

Create an open space.

Create a large curve.

The Wedding

M

Create these strokes with visual rhythm.

You may cross these strokes.

The Wedding

MF

Form an ellipse

Form an ellipse

You may cross these strokes.

The Wedding

Menu

C

Keep these curves rounded.

Form an ellipse.

Menu

CF

Create a large curve.

Keep these curves rounded.

Menu

M

Create these strokes with visual rhythm.

Form an ellipse.

Menu

MF

Create a large curve.

Create these strokes with visual rhythm.

Form an ellipse.

Menu

Welcome Home

C

Keep these curves rounded.

Keep these curves rounded.

Create an open space

Welcome Home

CF

Form an ellipse.

Form an ellipse.

Welcome Home

M

Elongate this stroke.

Elongate this stroke.

Create these strokes with visual rhythm.

Create these strokes with visual rhythm.

Welcome Home

MF

You may cross these strokes.

Form an ellipse.

Create these strokes with visual rhythm.

Welcome Home

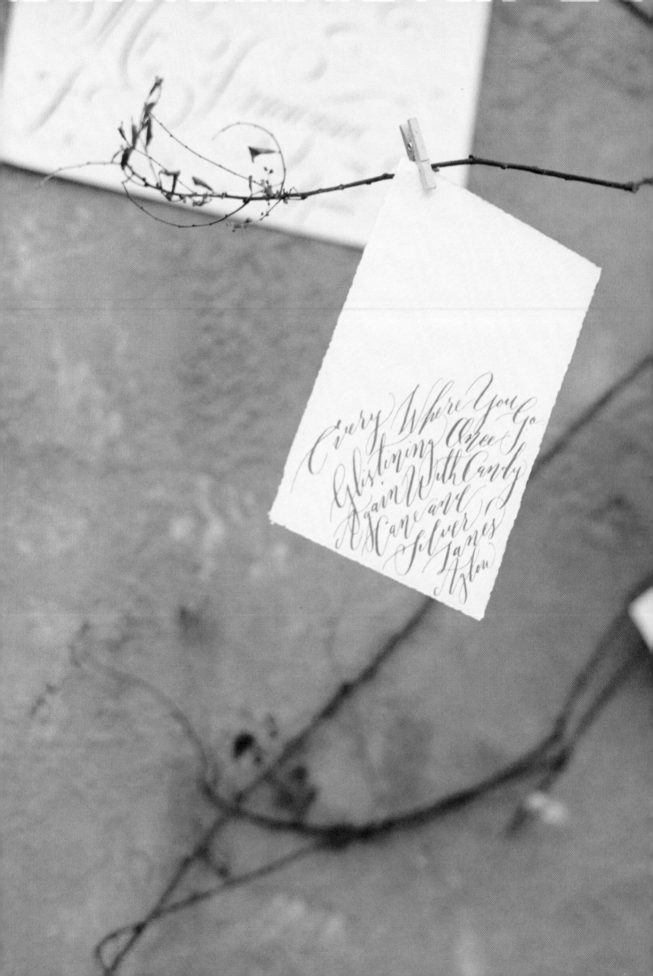

Every Where You Go
Glistining Once
Again With Candy
A Cane and Silver
Lanes
Aglou

Card Ideas And Paper Ornaments

I send cards with handwritten calligraphy to my friends and family for their birthdays. Through the time I spend with each card, each and every one comes to hold a special meaning. I also love making little projects out of various scraps of leftover paper. Calligraphy possesses a wondrous power that can breathe vibrant life into the merest of scraps. Those transformations are among my favorite moments.

When I'm thinking of my next project, my first thoughts go to its purpose. Will it be a card? A gift tag? Or something else? This answer will direct me to a certain size of paper. Next come questions about the color of the ink and the characteristics of the paper. The answers to these questions are determined by the project's theme, and it's at this point that I form an overall image of the finished item in my mind. When this process leads me to make a project using little scrap pieces of paper, I have too much fun to stop. The very process of creating something is itself exciting, and the joy at completing a project is an extra reward.

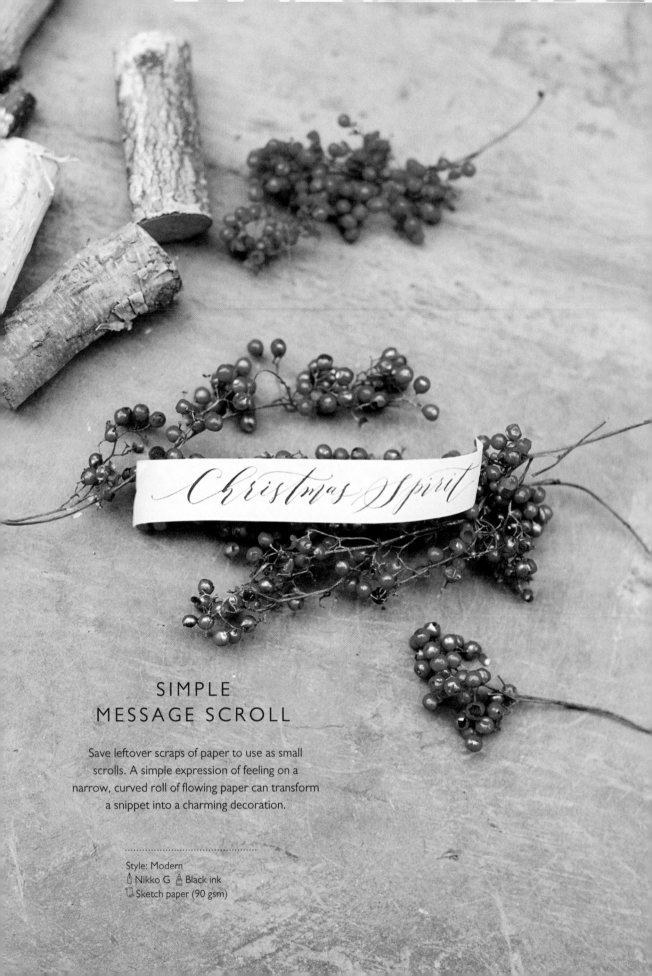

Christmas Spirit

SIMPLE
MESSAGE SCROLL

Save leftover scraps of paper to use as small
scrolls. A simple expression of feeling on a
narrow, curved roll of flowing paper can transform
a snippet into a charming decoration.

Style: Modern
🖊 Nikko G 🖋 Black ink
📄 Sketch paper (90 gsm)

SIMPLE MESSAGE SCROLL

How-To

Size	1 x 8¼ inches (2.5 x 21 cm)
Words	Christmas Spirit
Style	Modern
Materials	⬦ Nikko G
	⬥ Black ink
	▱ Sketch paper
	+ Pencil, ruler, cutting mat, craft knife, eraser, scissors

Determine Your Spacing

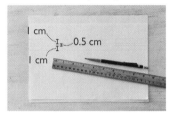

1 — Start with a piece of letter-size or A4 paper. Draw three horizontal guidelines spaced ½ inch, ¼ inch, and ½ inch (1 cm, 0.5 cm, 1 cm) apart.

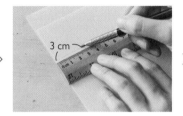

2 — Place your starting mark 1¼ inches (3 cm) from the left edge of the paper.

Lettering

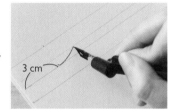

3 — Begin writing the C from your starting mark. If you like, you can use your pencil and the provided example to draft the letters.

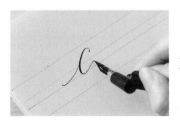

4 — After finishing your C, stop briefly and continue straight into the h.

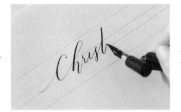

5 — Continue writing *Christ*. Your C, h, and t should have the same height.

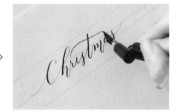

6 — Once you've written *Christmas*, cross the t and dot the i.

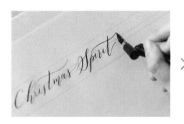

7 — Next write *Spirit* after *Christmas*, crossing the *t* and dotting the *i* at the end.

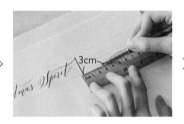

8 — Make a mark 1¼ inches (3 cm) to the right of the trailing edge of the *t*.

Make the Scroll

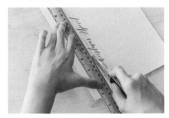

9 — Using a craft knife and ruler, cut the paper along the top and bottom guidelines.

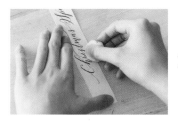
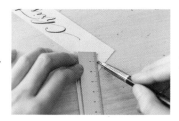
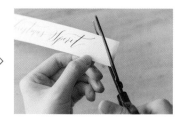

10 Once the ink is completely dry, erase your pencil guides.

11 Draw guidelines in the shape of a triangle on the left and right edges of your scroll.

12 Using scissors, cut along your new guidelines to remove the triangles.

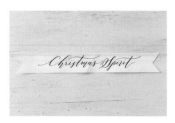
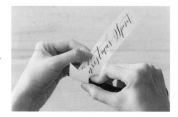

13 This is what the scroll should look like once the triangles have been trimmed away.

14 Gently wrap one end of the scroll around a pencil or other small cylindrical object to curl the scroll. Curl the other end in the opposite direction.

15 This is the finished scroll.

Note

Unlike the Classic Copperplate style, the Modern style does not require evenly spaced lettering; therefore you can write more freely.

Make the first letter large.

The crossbars should be long and flowing. You may want to save them for last.

Christmas Spirit

Shown at actual size.

Make the first entrance stroke long.

Make your exit stroke long and dynamic.

CHRISTMAS CARD

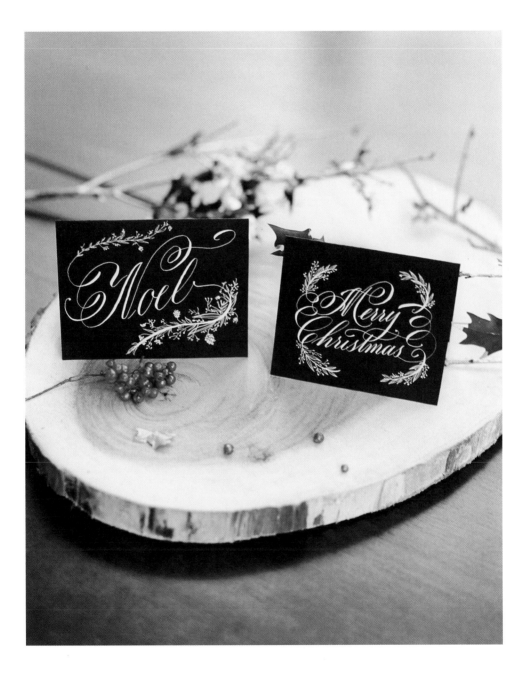

These tabletop tent cards are a simple way to liven up your home décor during Christmastime. You can even run a string through them for a stylish wall decoration.

...

Style: Classic Nikko G White ink
Black drawing paper

CHRISTMAS CARD

How-To

Size	3¼ x 4¼ inches (8 x 11 cm) after folding
Words	Noel, Merry Christmas
Style	Classic
Materials	🖊 Nikko G
	🗄 White ink
	🗒 Black drawing paper
	+ Paintbrush, dropper, water, small mixing container

Add White Ink to Your Nib

1 Pick up white ink with your paintbrush. Transfer the ink into your mixing container.

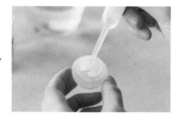

2 Using the dropper, add five or six drops of water to the mixing container.

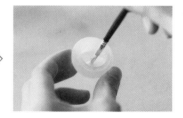

3 Mix the ink and water with your paintbrush.

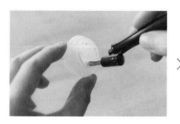

4 Dip your nib into the diluted ink.

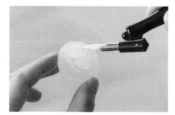

5 Make sure that ink has filled the nib's vent.

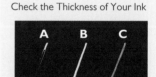

Check the Thickness of Your Ink

A | B | C

A) Not enough water
B) Correct amount of water
C) Too much water

Make the Card

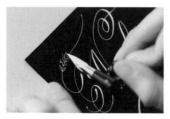

6 Write your chosen words. After you've finished, add a botanical illustration to the leading and trailing flourishes.

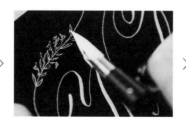

7 Add detail inside the leaves.

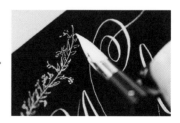

8 Draw finer lines and dots as you approach the end of the flourish.

Note

Write the words first, followed by flourishes and illustrations. Check the
balance of the overall image when adding your decorations.

Add the illustrations to the flourishes
after writing your words.

For both the upstrokes and downstrokes in this
illustration, keep your pressure light and your lines fine.

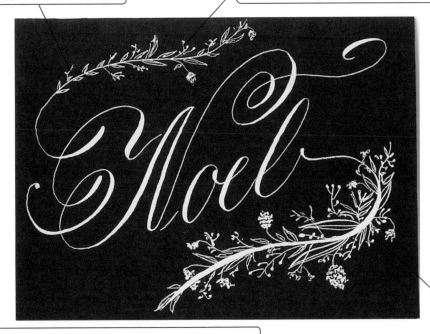

Draw this
illustration at
the very end.

If you like, you can draw the flourish in pencil first. Once you're satisfied
with the composition of your layout, you can then finish it in ink.

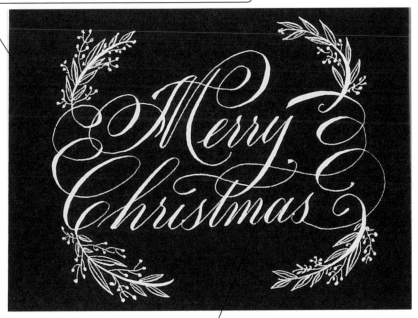

Shown at actual size.

For the last stroke of your lettering, write the *t*'s crossbar and cross it through
the *y*. Although the ends of the stroke are curved, take care not to let it tilt.

POSTCARDS

I love writing postcards and as well as collecting them. I'll never let go of any that have handwriting on the back. When writing on postcards myself, I hope that it will one day become someone else's treasure.

Style: Classic, Modern ✒ Hunt 101 🖋 Black ink
📜 Fine Italian paper (260 gsm)

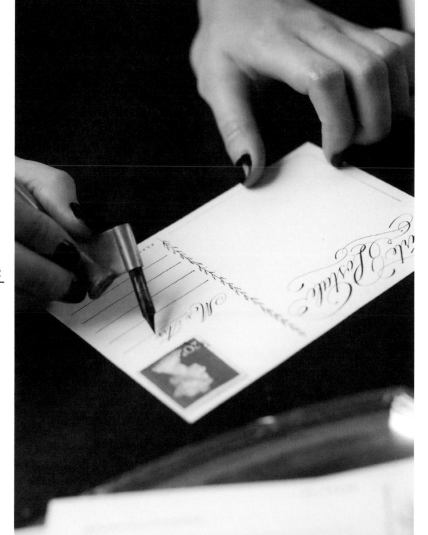

1 I enjoy stamps as much as I do postcards. When I come across one with a unique image, I can't help but add it to my collection.

2 Put love and feeling into your writing. As you write, try to take a few moments to savor the memories of times spent with the person to whom you're writing.

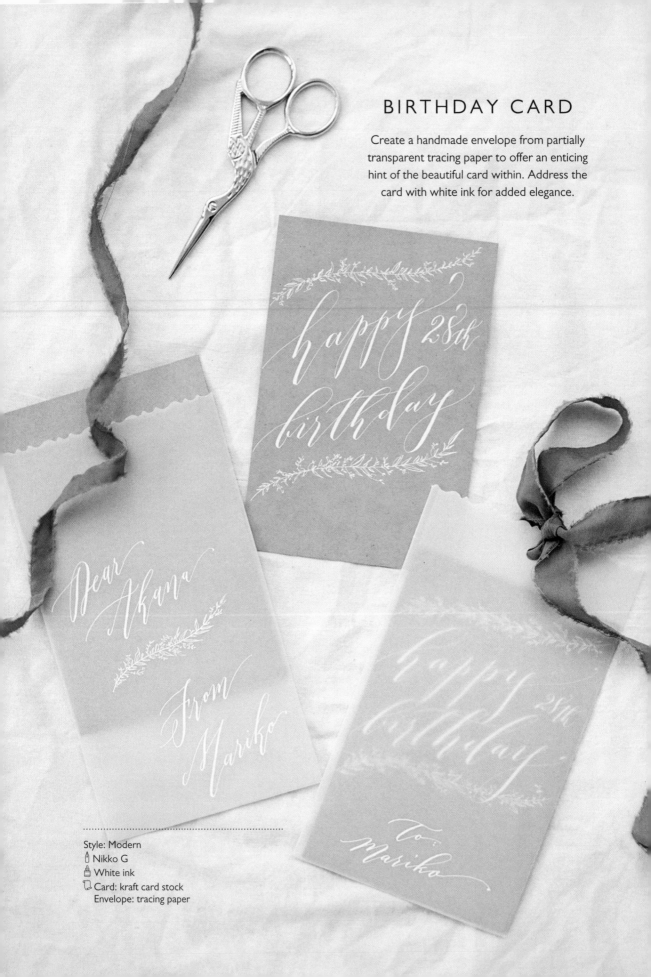

BIRTHDAY CARD

Create a handmade envelope from partially transparent tracing paper to offer an enticing hint of the beautiful card within. Address the card with white ink for added elegance.

Style: Modern
Nikko G
White ink
Card: kraft card stock
Envelope: tracing paper

BIRTHDAY CARD

Size	Envelope: 7½ x 4 inches (19 x 10 cm) Card: 5¾ x 4 inches (14.8 x 10 cm)
Words	happy 28th birthday
Style	Modern
Materials	✒ Nikko G
	🖋 White ink
	📄 Card: kraft card stock Envelope: tracing paper (letter-size or A4)
	+ Craft knife, cutting mat, ruler, glue, paper edger scissors, hole punch, ribbon

Make the Envelope

1 Center the card stock on the tracing paper with the short edge facing you. Leave a larger margin at the top.

2 Fold the right side of the tracing paper over the card stock. The edge of the card stock should be nested in the fold.

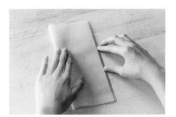

3 Do the same for the left side of the tracing paper.

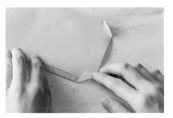

4 Fold the bottom corners, then fold the entire bottom over the card stock. The finished fold should nest the bottom edge.

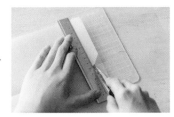

5 Unfold the tracing paper. With the craft knife and ruler, cut along the bottom creases as shown.

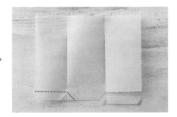

6 This is the paper with the bottom right side cut away. Cut the bottom left side in the same manner.

Tab for gluing

7 This is what the tracing paper should look like after both cuts have been made.

8 Place glue on the bottom tab. Fold in the right and left sides, then fold the tab over to glue the envelope together.

9 Cut the open top edge of the envelope with paper edger scissors.

 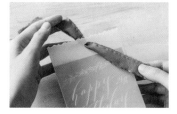 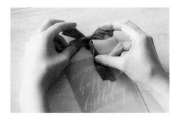

10 Using the hole punch, punch a hole in the envelope's top flap.

11 Insert the ribbon through the hole.

12 Finish by tying the ribbon.

Create the Card

1 Draft your lettering and illustration with a pencil. You can refer to the provided sample as a guide.

2 Write over the penciled words in white ink. (For more instructions, refer to Christmas Card on page 42.)

Note

Extend your entrance and exit strokes to the very edge of the card to give your message a dynamic feel.

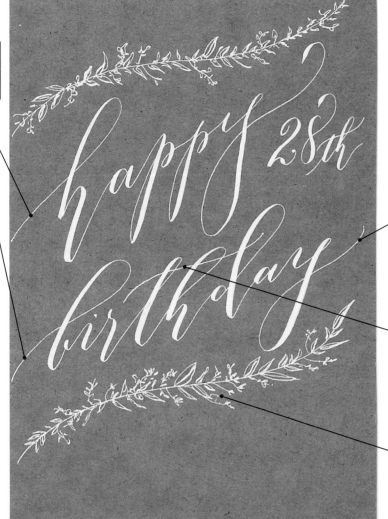

Make your first upstrokes long. Start at the edge of the card.

Your final upstroke should also stretch almost all the way to the card's edge.

Keep the *t*'s crossbar aligned with the rest of the word as a whole. The crossbar should be your last stroke of lettering.

Draw the illustrations after you've written everything else. You can draw them first in pencil, then go over them with white ink.

Shown at actual size.

THANK YOU CARD

Making your own envelope liners is fun, and the possibilities are endless—try painting in watercolor to create graduated shades of color. Use the same gradation for the card's text to tie it all together.

Thank You

Thank You

Style: Classic
🖋 Hunt 101 🎨 Watercolor / gouache
📄 Card and envelope: fine Italian paper
Envelope liner: sketch paper (90 gsm)

THANK YOU CARD

Size	3½ x 5¼ inches (8.8 x 13.5 cm) for card , 3½ x 5½ inches (9 x 14 cm) for envelope, and 5½ x 5⅜ inches (14 x 13.8 cm) for envelope liner
Words	Thank You
Style	Classic
Materials	✒ Hunt 101
	🖊 Watercolor paint (red, lavender, deep blue, light blue, green, gray)
	🗒 Card and envelope: fine Italian paper Envelope liner: sketch paper
	+ Pencil, ruler, paint palette, paintbrush, water, scissors, eraser

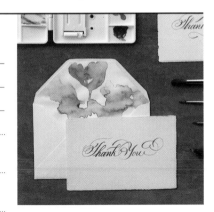

Make the Envelope Liner

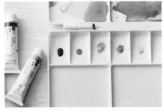

1 — Trace around the edges of the open envelope on the sketch paper. This will become your envelope liner.

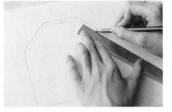

2 — Measure and trace an interior margin for the flap. The margin lines should be roughly ⅜ inch (1 cm) from the edge.

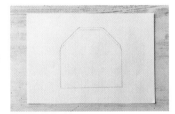

3 — This is the finished tracing with the margin lines drawn.

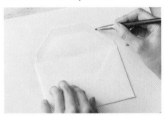

4 — Place the paint onto your palette. (From left to right: red, lavender, light blue, green and gray.)

5 — Mix red and lavender with your brush and thin the mixture with water.

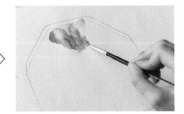

6 — Using that mixture, paint a heart at the top of the envelope liner.

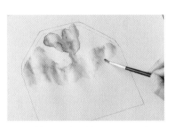

7 — Mix together blue, green, and gray, and thin with water. Fill in the area below and around the heart with this color.

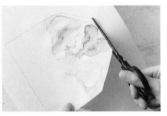

8 — After the paint has dried, cut along the borders of your envelope liner. When you reach the flap, cut along the interior margin lines.

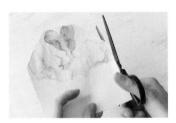

9 — Trim the left and right sides of the liner as needed to fit the liner inside the envelope.

Make the Card

10 With the ruler and pencil, draw your guidelines.

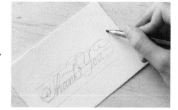

11 Still using a pencil, write your message.

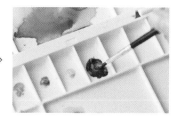

12 Mix red and lavender with your paintbrush.

13 Prepare your palette with the other colors that you'll use (the red and lavender mixture, deep blue, light blue, green.)

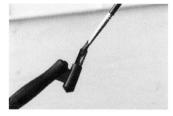

14 Using your paintbrush, apply the red and lavender mixture to your nib.

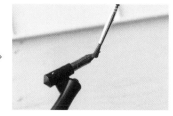

15 Be sure to coat both sides of the nib.

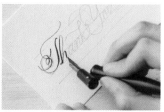

16 Using the red and lavender mixture, write the *T* and the *h*.

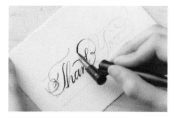

17 Clean your paintbrush with water, apply deep blue and continue writing the *a*, *n*, and *k*.

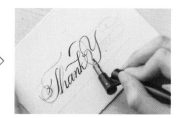

18 Clean your paintbrush with water, then apply light blue onto your nib and write the *Y*.

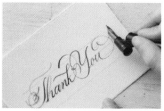

19 Clean your paintbrush with water, then apply green onto your nib and write the *o* and *u* and draw the flourish.

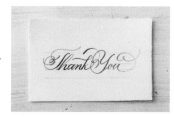

20 This is the card with the message. After the paint has completely dried, erase the pencil guidelines.

21 Finally, insert the liner into your envelope, followed by the card.

Note

Allow plenty of room for the initial and final flourishes. Try overlapping your words in the middle.

Shown at actual size.

The curves of your flourish should suggest an ellipse. Give the flourish plenty of space. Let it breathe.

Overlap the flourishes on the *k* in Thank and the *Y* in You.

This flourish should be large and flowing.

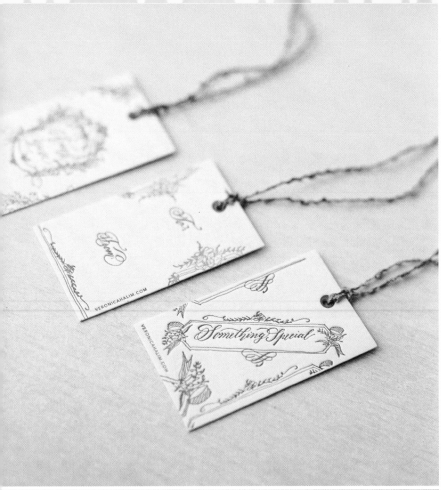

SMALL TAGS

When printed by letterpress, handwritten calligraphy becomes a part of the paper, creating a striking effect. Use cotton paper for a well-defined imprint. Several online services can create letterpress plates from your digital files and make letterpress prints for you.

..

Style: Classic
🖋 Hunt 101, then digitized for a letterpress plate
🍶 Black ink, then digitized
📄 Cotton paper (400 gsm)

SIMPLE MINI CARDS

For these mini cards, I created the border with a rubber stamp and kept the calligraphy simple with only single initials. The irregularities in the stamped border give the cards a vintage feel.

..

Style: Classic
🖋 Hunt 101
🍶 Black ink
📄 Fine Italian paper (260 gsm)

SMALL QUOTE CARD

This card contains a line from the poem "The Old Astronomer." Bluish gray paint makes the night sky, and gold ink evokes glittering stars. In this way, the imagery and emotion of the poem are given form.

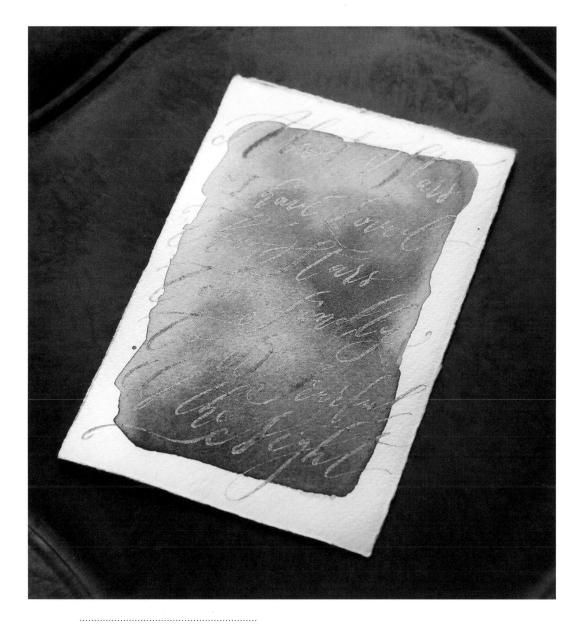

Style: Modern
🖊 Hunt 101
🎨 Watercolor, gold ink
📄 Fine Italian paper

SMALL QUOTE CARD

How-To

Size	5 x 3¼ inches (13 x 8.5 cm)
Words	About Stars, I have Loved The Stars too Fondly to Be Fearful Of the Night
Style	Modern
Materials	🖊 Hunt 101
	🎨 Watercolor paints (blue, purple, black), gold ink
	📄 Fine Italian paper
	+ a few sheets of paper to lay underneath as a cushion, practice paper, small mixing container, water, paintbrush, pencil, eraser

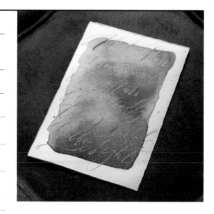

Paint the Background

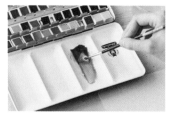

1 Add blue, purple, and black to your palette and mix them together to create gray. Thin the mixture with water.

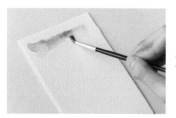

2 Leaving a ⅜-inch (1 cm) margin, begin filling in the background of the paper with paint.

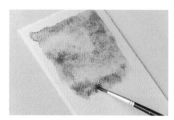

3 Make lighter and darker patches of color.

4 This is the finished background. The paint needs to completely dry before you return to the card. Meanwhile, practice creating your design.

Practice Your Calligraphy

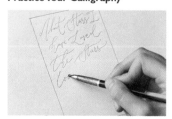

5 Draw a border that matches the size of the card on your practice paper. Then write the quote in pencil.

6 When you've finished, adjust and refine the layout until you find the right balance for the words.

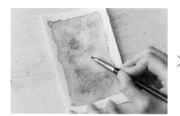

7 Using your practice sketch as a guide, write the phrase on the painted card with a pencil. Make sure the paint is dry.

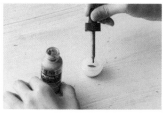

8 Place a small amount of gold ink into a small mixing container.

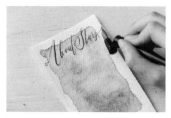

9 With ink, write over your pencil guides. Try extending your strokes beyond the grey borders to create a feeling of movement.

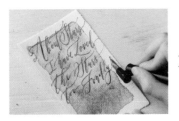

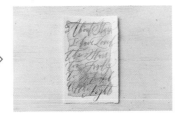

10 Remember to keep your upstrokes thin and your downstrokes thick, and give rhythm to the shape of your words by varying the size of your letters.

11 This is the card with the finished writing.

12 Finally, after all the ink has completely dried, erase your pencil work.

Note

Create an artistic and poetic feel by extending your upstrokes and varying the size of your letters.

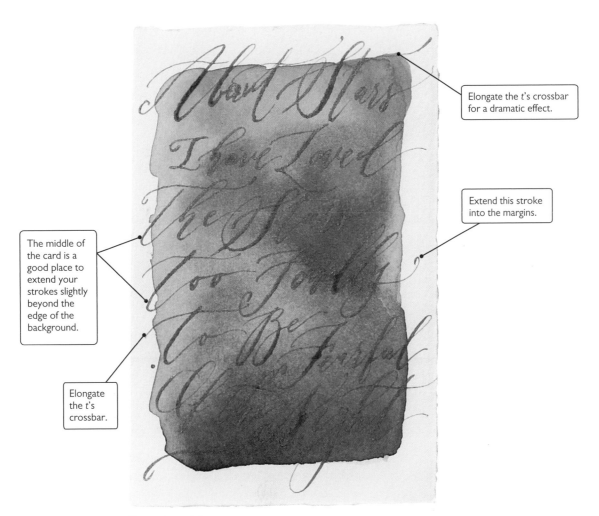

Elongate the *t*'s crossbar for a dramatic effect.

Extend this stroke into the margins.

The middle of the card is a good place to extend your strokes slightly beyond the edge of the background.

Elongate the *t*'s crossbar.

Shown at actual size.

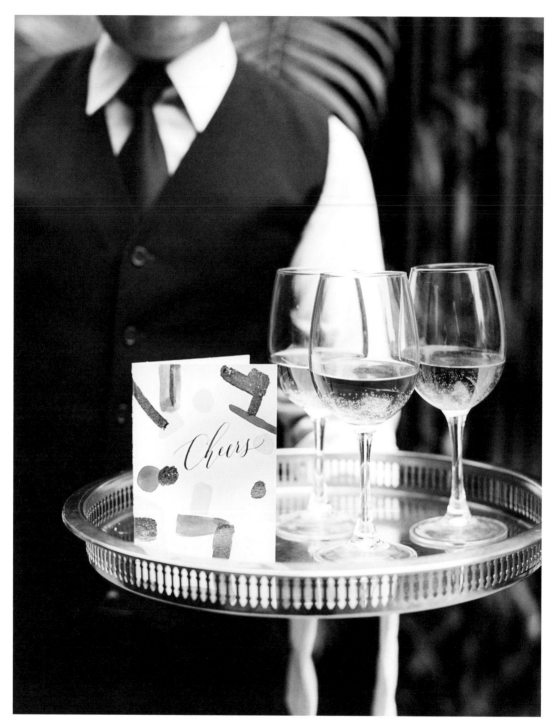

Whenever I see the festive colors of confetti, I'm reminded of the fun times that I had at parties. These cards, inspired by confetti, are perfect for offering congratulations.

Style: Modern
⌖ Hunt 101
⚗ Black ink, watercolor, gold foil
▢ Watercolor paper (300 gsm)

CONGRATULATIONS CARD

Gold foil adds dashes of glamour to the pastel watercolor or gouache. The combination makes cards that truly feel special.

CONGRATULATIONS CARD

How-To

Size	4 x 5½ inches (10 x 14.2 cm) after folding
Words	Congratulations
Style	Modern
Materials	⬗ Hunt 101
	⬗ Black ink, watercolor paint (gray, dark blue, light pink), gold foil
	⬗ Watercolor paper
	+ Ruler, craft knife, cutting mat, pencil, two paintbrushes, gilding size (or adhesive), eraser

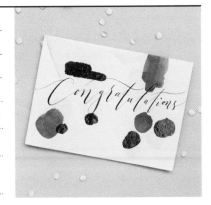

Paint the background

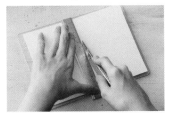

1 — Using a ruler and the blunt side of your craft knife's blade, create a fold line in the center of your paper and fold the paper in half.

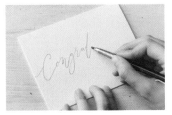

2 — Write your calligraphy in pencil. The message should be centered vertically on the card. Begin the first entrance stroke at the card's left edge for an expansive feel.

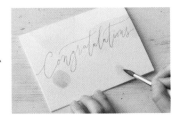

3 — Mix together the dark blue and gray paints, then add water to make a light blue color. Paint the background of the card using this picture as a reference.

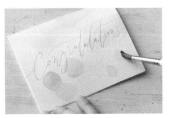

4 — Thin the light pink with water, and paint the card using this as a reference. Overlap the pink and blue areas in several places.

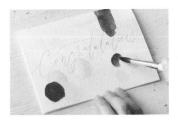

5 — Add areas of dark blue paint using this picture as an example.

Apply the gold foil

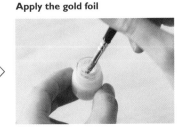

6 — Pick up the gilding size with your paintbrush.

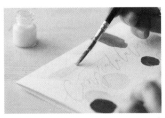

7 — Paint the gilding size where you want the gold foil to be. Let it dry for 15 to 20 minutes; it will remain tacky.

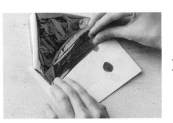

8 — Place the gold foil over one of the areas with dried size.

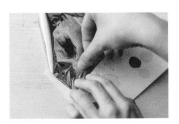

9 — Gently slide a fingernail over the foil to transfer the foil to the paper.

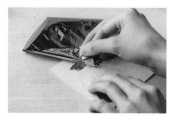 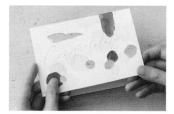

10 — Slowly peel away the gold foil sheet.

11 — This is what the gold foil should look like when applied to the paper.

12 — Repeat in the other areas where you painted the gilding size.

Write the Message

13 — Using your pencil work as a guide, write your calligraphy in ink, remembering to keep the upstrokes slender and the downstrokes thick.

14 — The two crossbars should be written last. The crossbar of the second t should be breezy, almost like it might flow all the way off the edge of the card.

15 — Finally, after the ink has completely dried, erase the pencil marks.

Note

Vary the size of your letters and the thickness of your strokes. An irregular rhythm in your calligraphy will accentuate the freeform nature of the modern script.

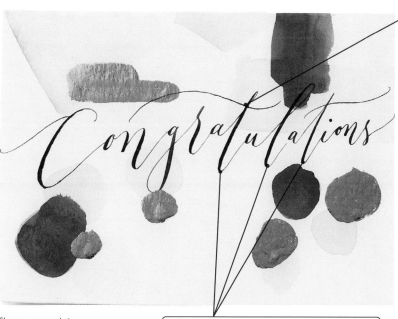

The crossbar of the t should be long, flowing, and dramatic.

Shown at actual size.

Lengthen the downstrokes of each t and the l so that they extend a little below your baseline.

VINTAGE LABEL CARDS

I collect vintage product labels found on perfume bottles and food items. These cards are my attempt to re-create the hues and designs unique to that period with watercolor paint.

..

Style: Classic
🍾 Hunt 101 ✒ Black ink, watercolor
🗒 Watercolor paper (300 gsm)

VINTAGE PERFUME CARD

Bottles of Buly® 1803 perfume inspired me to make this design. The combination of watercolor and calligraphy evokes the romantic mood of olden times.

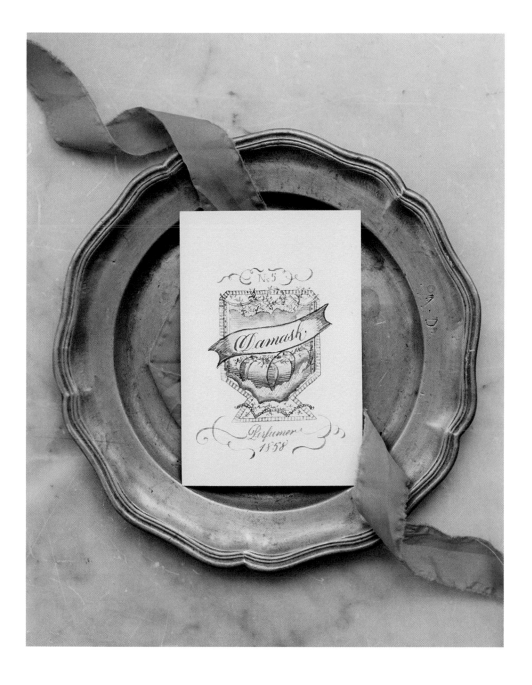

Style: Classic 🖊 Hunt 101 🏺 Watercolor
📄 Watercolor paper (300 gsm)

BUTTERFLY CARDS

These cards evoke the image of beautiful butterfly
wings and can be used in a wide variety of ways, including
as place cards or gift tags.

Style: Classic
🖊 Hunt 101
🎨 Metallic watercolor palette, gray gouache
📄 Watercolor paper (300 gsm)

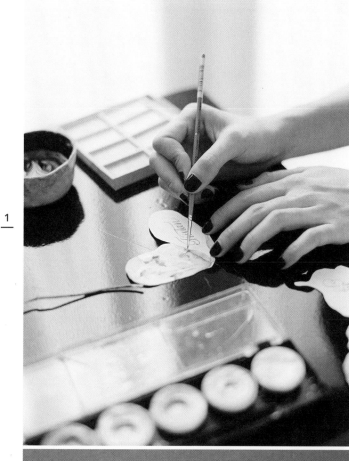

1

2

1 Add ethereal color to the wings with pastel watercolors and pair with a classic-style script.

2 Create a shimmering effect with metallic paints.

Monograms And Stationeries

Monograms are typically one or two initials of an individual (or individuals) combined with a decoration. Much like logos, monograms express an identity and tell a story. They can be found on a wide variety of objects, such as household items, stationery, silverware, dinnerware, and linens. I've created many different kinds of monograms, from the initials of a betrothed couple on their wedding invitations to a family's initials on personalized stationery. The potential styles and designs are infinite, and each finished monogram is the only one just like it in the entire world. Whenever I create something special like that, I'm filled with joy.

When I'm working on a new design, I often browse through archives of historical monograms. I carefully observe royal monograms to learn from their balance and beauty and to study how their meaningful elements interact. My designs go through multiple sketches and revisions before they take final shape.

ASSORTMENT OF
MONOGRAM SKETCHES

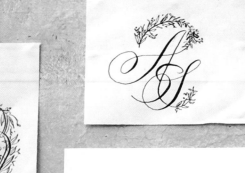

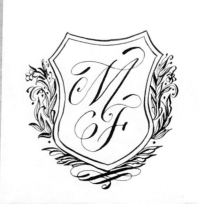

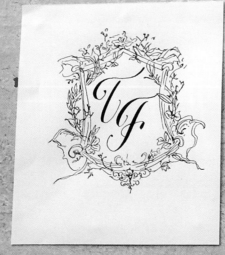

These are sketches of monograms
commissioned for various purposes, including
weddings, logos, personalized stationery,
embroidered napkins, and more.

..

Style: Classic, Modern

Hunt 101, Nikko G, Leonardt EF Principal

Black ink

Smooth copy paper

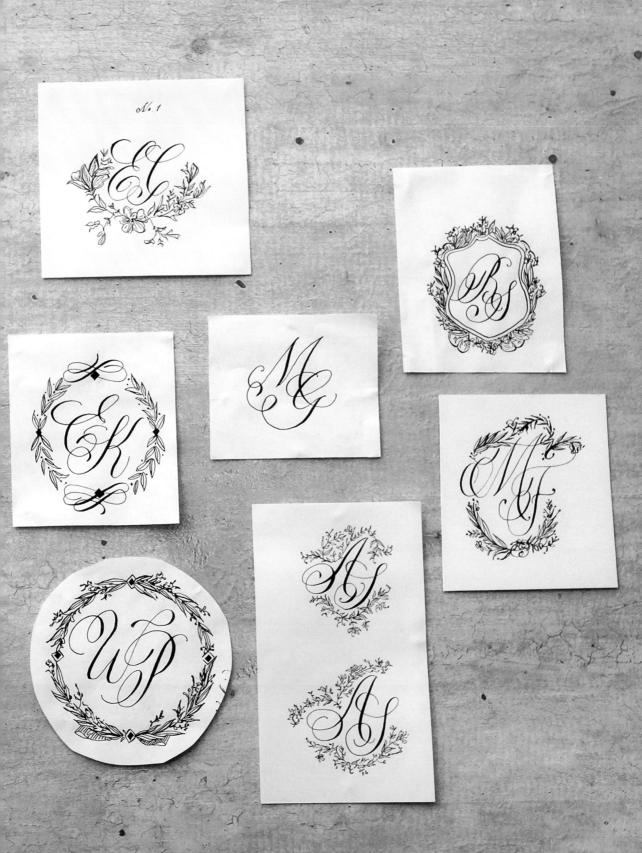

ASSORTMENT OF MONOGRAM SKETCHES

Size	Each approximately 2 inches (5 cm) in diameter
Words	MG, AS, EK
Style	Classic
Materials	⬙ Hunt 101
	⬚ Black ink
	⬛ Smooth copy paper
	+ Cup or glass, pencil, eraser

Make the Monograms

1 — Using the bottom of a glass or other round object, draw a circle.

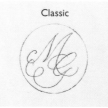

Classic

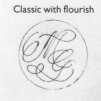

Classic with flourish

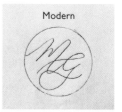

Modern

2 — Write the initials within the circle. The key to combining two letters is deciding how and where they will overlap. Overlapping the longer strokes will generally work well.

Write in a Classic Script (MG)

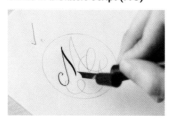

1 — Design the composition of the M and G in pencil. Then start writing the M in ink.

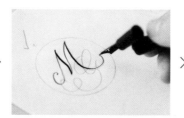

2 — Gradually ease the pressure on the last downstroke and end it with a fine line.

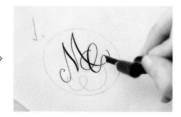

3 — Start writing the G. It should appear as if it's hanging from the M's elongated exit stroke.

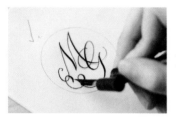

4 The G's exit stroke should over-lap with the M's entrance stroke.

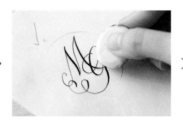

5 After the ink has completely dried, erase the pencilwork.

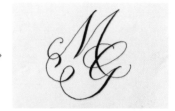

6 This is what the completed writing looks like.

Embellish the Letters (AS)

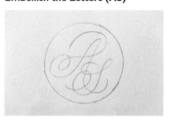

1 Design the AS monogram in pencil.

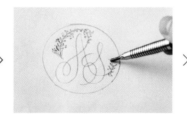

2 When deciding where to add a decorative illustration, seek out long outside strokes and places where the calligraphy isn't already crowded.

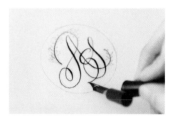

3 Write the A and then the S.

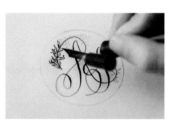

4 Add an illustration to the A's flourish. Draw with slender strokes, using only the tip of the nib and light pressure.

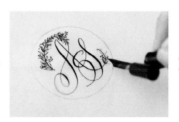

5 Add an illustration to the A's exit stoke.

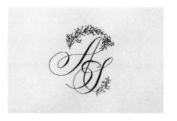

6 Finally, once the ink has completely dried, erase the pencilwork.

Surround the Letters with an Illustration (EK)

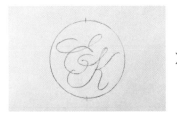

1 — Design the *EK* monogram in pencil.

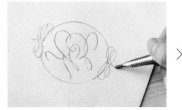

2 — Add two horizontal-eight strokes (page 23) along the outer circle, one above the letters and one below. Rotate upside down to draw the top decoration.

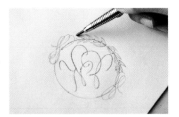

3 — Draw leaves along the outer circle. Rotating the paper as you go will make drawing the leaves easier. Add dots in the gaps between the leaves.

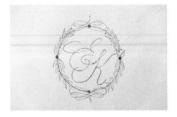

4 — Draw diamonds at the four cardinal points.

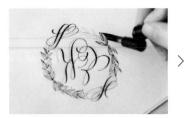

5 — Ink in your pencil work in the same order you designed it, except for the circle. The circle should only be used a guide for creating the design—don't trace it.

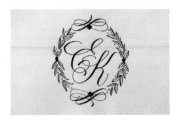

6 — Finally, once the ink has completely dried, erase the pencil work.

Note

When designing a monogram with two initials, create places where the letters overlap. Leave plenty of space for the flourishes. Add loops and sweeping curves.

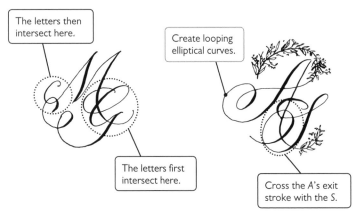

The letters then intersect here.

The letters first intersect here.

Create looping elliptical curves.

Cross the *A*'s exit stroke with the *S*.

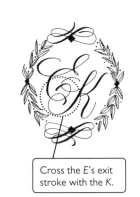

Cross the *E*'s exit stroke with the *K*.

Shown at actual size.

EMBOSSING POWDER MONOGRAM

Embossing powder can transform blank stationery into one-of-a-kind, personalized items. When given a monogram, initials, or a name, the stationery will feel like something special.

..

Style: Classic
🖋 Hunt 101 🧴 Gold embossing powder, glycerin, gum arabic
📄 Fine Italian paper

EMBOSSING POWDER MONOGRAM | How-To

Size	3½ x 5½ inches (9 x 14 cm) after folding
Words	TF
Style	Classic
Materials	⬙ Hunt 101
	⬙ Gold embossing powder, glycerin, gum arabic
	⬙ Fine Italian paper envelope
	+ Small mixing container, two paintbrushes, water, dropper, pencil, a few sheets of paper to lay underneath as a cushion, embossing heat gun

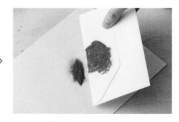

Make the Embossing Paste

1 — Place about twenty drops of glycerin into a small mixing container.

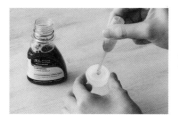

2 — Using a dropper, add six to eight drops of gum arabic into the small mixing container.

3 — Using a paintbrush, stir the mixture until it becomes sticky.

Create the Embossed Letters

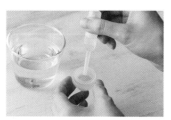

4 — If the mixture becomes too viscous, you can a few drops of water. This is the embossing paste.

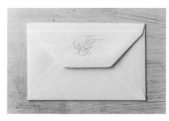

5 — Using a pencil, write the monogram (*T* and *F* in this example) on the flap of your envelope.

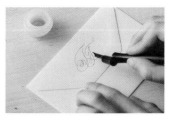

6 — Apply the embossing paste to your nib, then write over your pencil work. If you aren't applying enough paste, you can retrace as needed.

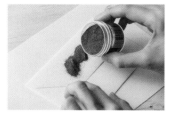

7 — Before the paste dries, sprinkle embossing powder onto the paste.

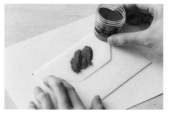

8 — This is what the application of the embossing powder should look like. Add enough, as shown.

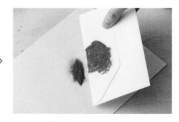

9 — Tilt the envelope at an angle to remove the excess powder.

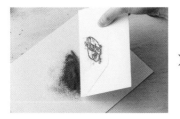

10 The powder will stay on the areas with paste, and the letters will begin to appear.

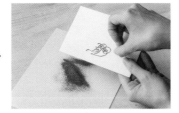

11 Tap the paper with your finger to remove more excess powder.

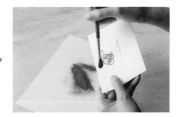

12 Taking care not to brush away too much powder from the letters, use the brush to wipe away the remaining excess powder.

Heat the Embossing Powder

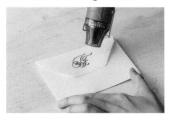

13 Heat the area with the letters using an embossing heat gun.

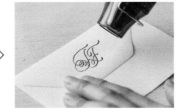

14 The letters will slowly begin to rise.

15 When the letters have risen, as shown in the photo, the embossing is finished.

Embossing Heat Gun

Sometimes called an embossing heat tool, this heat gun melts embossing powder, allowing it to rise. Always use a heat gun specifically designed for use on embossing powder. A typical hair dryer will not work for embossing.

Note

Keep your flourishes elliptical. Crossing your letters will create a more elegant look.

Write round, looping flourishes.

The *F*'s flourish overlaps the *T*.

Keep the strokes of your *T* and *F* parallel.

Shown at actual size.

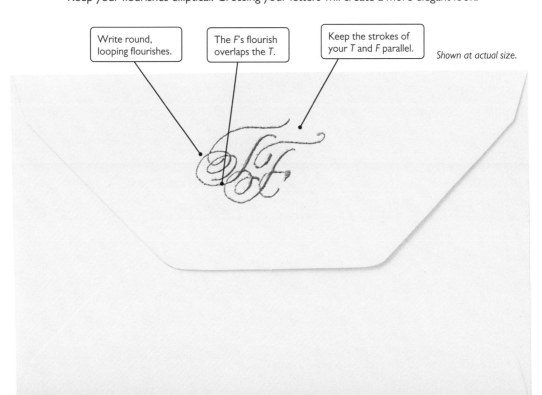

ANTIQUE STYLE MONOGRAM

A royal monogram I came across in an archive of vintage materials inspired these images.
A faint brushing of metallic paint helps bring out an air of nobility.

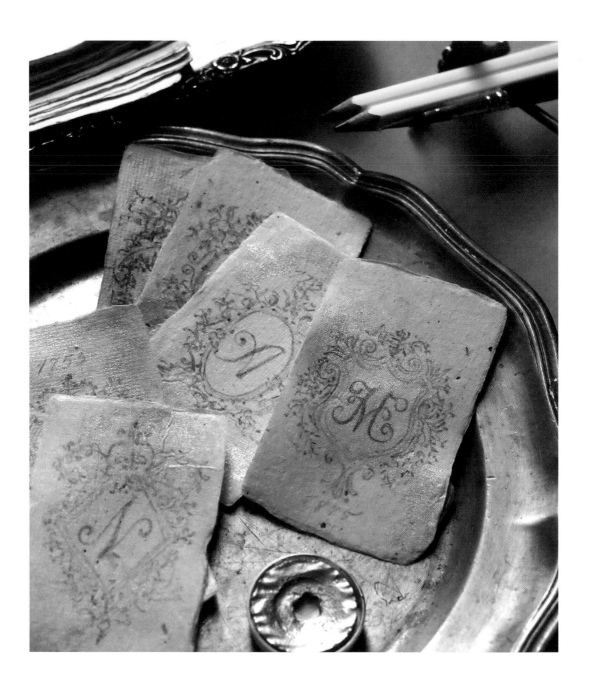

Style: Classic
✒ Colored pencil, metallic color
palette
▯ Japanese mini handmade paper

1

2

1 Add water to the metallic paint to achieve the right consistency for writing letters and illustrations.

2 I chose to write with colored pencils because I wanted these to not feel overly finished. I also kept the lines very fine.

BOTANICAL ILLUSTRATION
MONOGRAM

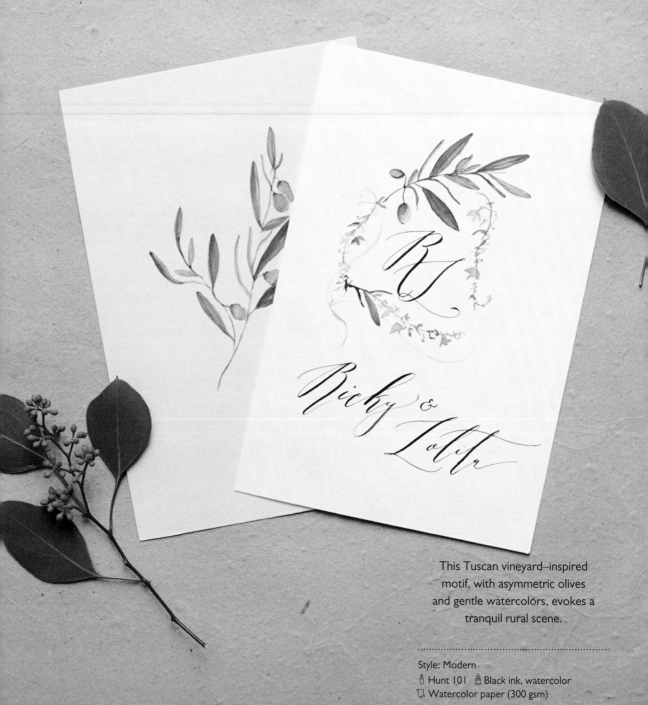

This Tuscan vineyard–inspired
motif, with asymmetric olives
and gentle watercolors, evokes a
tranquil rural scene.

...

Style: Modern
🖊 Hunt 101 🖋 Black ink, watercolor
📄 Watercolor paper (300 gsm)

BOTANICAL ILLUSTRATION MONOGRAM

How-To

Size	7¾ x 6 inches (19.5 x 15 cm), 4 x 3¼ inches (10 x 8 cm) for illustration
Words	RL
Style	Modern
Materials	⬙ Hunt 101
	⬙ Black ink, watercolor paint (yellow-green, deep green)
	⬙ Watercolor paper
	+ Cup or glass, pencil, two paintbrushes (fine and extra fine), paint palette, water, eraser

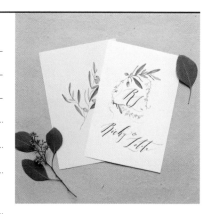

Sketch the Monogram and Illustration

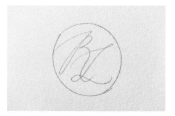

1 Write the initials in pencil. Refer to the instructions on how to design a monogram on page 68.

2 Roughly sketch in where you want to place the illustration around the circle.

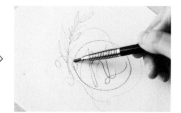

3 Draw the olive branches. They can dip into the circle, if you like.

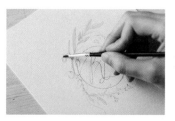

4 Draw other delicate leafy plants as if they are entwined around the olive branch.

5 This is an example of the finished sketch. Paint the illustration first and ink the calligraphy last so that the letters stand out.

Paint the Illustration

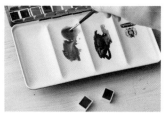

6 Load the yellow-green and deep green paints onto a palette and thin each with water.

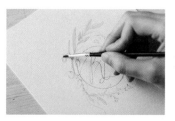

7 Using a fine paintbrush, paint the olive leaves and olives with thinned yellow-green paint.

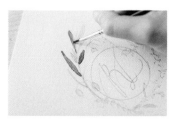

8 Let the paint dry, then add the deep-green paint to the same areas.

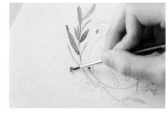

9 Add more body to the olives with a wet brush and heavier deep green.

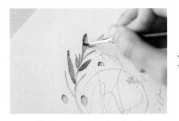

10 Darken one side the olive leaves with a slightly thinned deep green.

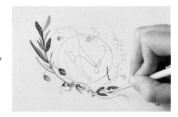

11 Using an extra-fine brush, paint the delicate leaves and vines with thinned yellow-green paint.

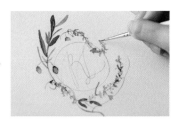

12 With the same paint and brush as step 11, paint in the plants on the right side.

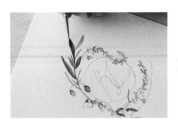

13 Pick up heavier deep green with the extra-fine brush and paint in the veins on the leaves.

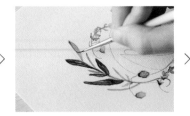

14 With the same paint and brush used in step 13, draw the outlines of the leaves.

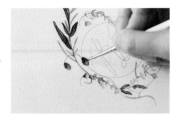

15 With the same paint and brush used in step 13, draw the outlines of the olives.

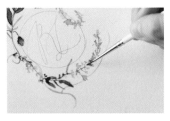

16 With the same paint and brush used in step 13, add darker areas to the plant on the right side.

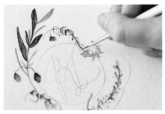

17 With the same paint and brush as step 13, paint the vines on the right side.

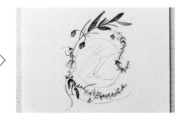

18 Let the paint dry. This is what the finished illustration looks like.

Write the Initials

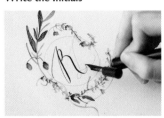

19 After the watercolor illustration has completely dried, write the *R*.

20 Write the *L*.

21 Finally, after all the ink has completely dried, erase your pencil work.

Note

Write the initials slightly off-center to add a sense of movement.

Shown at actual size.

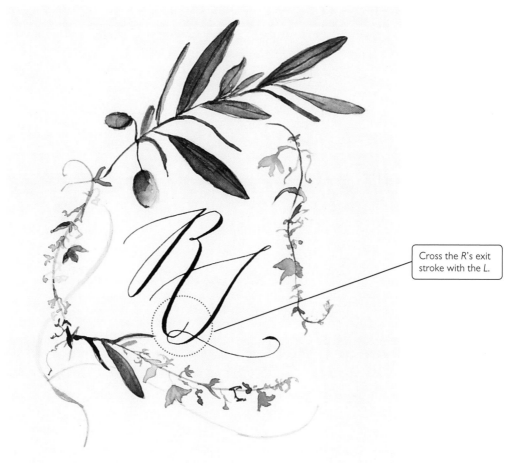

Cross the *R*'s exit stroke with the *L*.

VICTORIAN
SQUARE MONOGRAM

This ornate, gold ink monogram was written on
deckle edge paper for a decorative, Victorian-era style.

..

Style: Classic ✒ Hunt 101
🖋 Gold ink
📄 Handmade paper

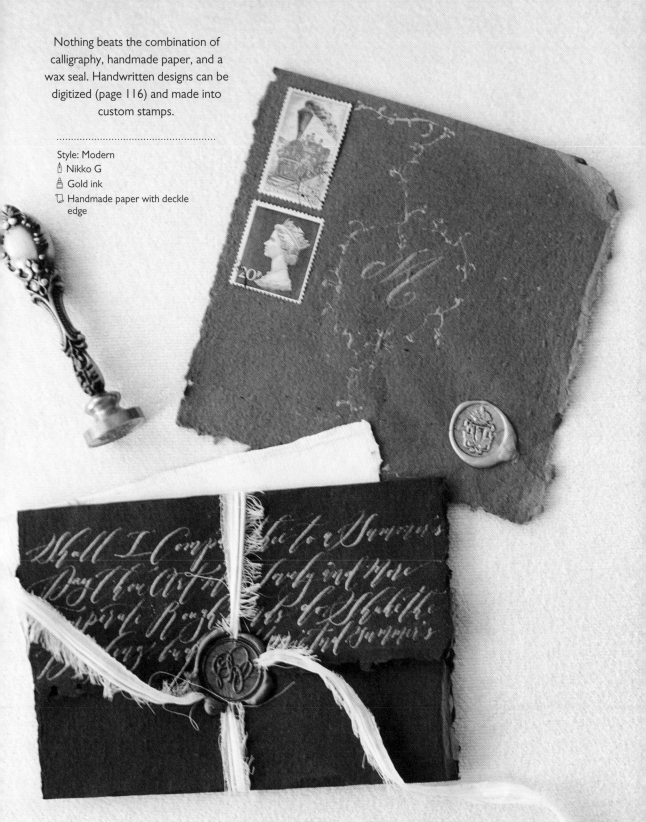

Nothing beats the combination of calligraphy, handmade paper, and a wax seal. Handwritten designs can be digitized (page 116) and made into custom stamps.

Style: Modern
✒ Nikko G
🖋 Gold ink
🗒 Handmade paper with deckle edge

HANDMADE VINTAGE LETTER

EMBOSSED MONOGRAM

Like wax seals, embossing stamps can be made from your digitized designs (page 116). Calligraphy pressed into paper, without ink, possesses its own distinctive beauty.

..

Style: Classic 📜 Fine Italian paper

When using an embosser, press firmly for about ten seconds. I recommend using thin and soft cotton paper.

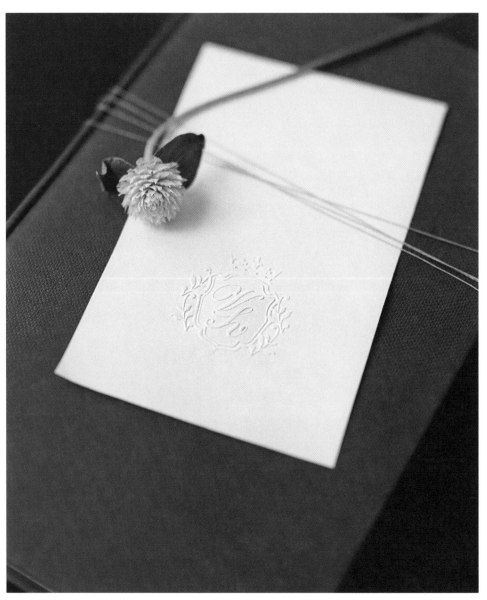

PERSONALIZED
STATIONERY

This leather business card holder with a wax seal carries
monogrammed cards. The combined effect conveys luxury.

..

Style: Classic Hunt 101
Gold ink
Fine Italian paper

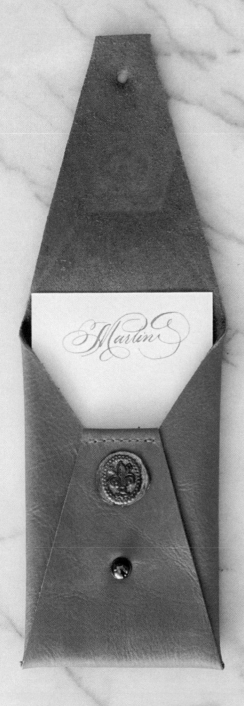

CHAPTER

4

―

Styling with Flowers And Antiques

Plants are a marvelous treasure given to us by the earth. Flowers, leaves, stems, seeds, fruit....I am constantly captivated by their delicate beauty. Like people—and like calligraphy—each plant is different. Their gently bending stalks are like long, slender pen strokes. They change with the seasons—cherry blossoms in the spring, turning leaves in the fall—and these changes inspire me with new ideas.

If plants are presents given to us by nature, then antiques are presents given to us by history. They are imbued with the culture of our forebears and exemplify the techniques of skilled craftsmen. Culture and craft combine to create an aura of the nostalgic and the romantic that present-day goods can't express.

By connecting flowers, antiques, and calligraphy, we can create a new harmony. For this chapter, I've collaborated with one of my favorite florists, Junji Noritake of Flower Noritake, and Yuri Noritake of the delightful antique shop Tisane Infusion.

JAR NECKLACE TAG

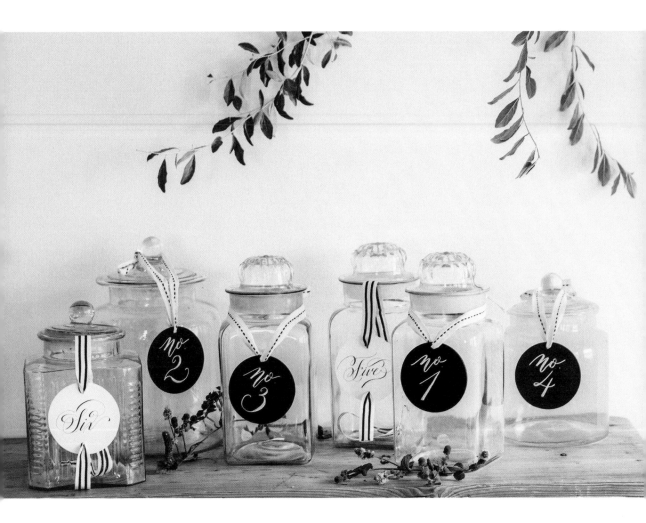

These antique glass jars are from Tisane Infusion. I've
chosen a simple, modern design for the tags that don't
impair the beauty of the glass jars' transparency.

Classic (on paper), Modern (on wooden tag)
Hunt 101 Black ink, white chalk marker
Drawing paper, black chalkboard wood ornament

JAR NECKLACE TAG

How-To

Size	3½ inches (9 cm) in diameter
Words	no. 1, no. 2, no. 3
Style	Modern
Materials	⬧ White chalk marker
	⬧ Black chalkboard wood ornament
	+ Water, ribbon, paper towel (optional)

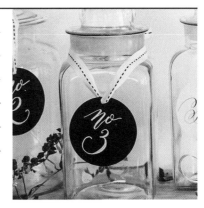

Write the Letters and Numbers

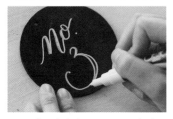

1 Decided where you want the letters or numbers to have thicker strokes. Draw an extra outside line around these areas.

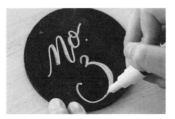

2 Fill in the spaces between the outlines to create a thicker stroke. Insert a ribbon through the hole at the top of the ornament.

If You Made a Mistake…

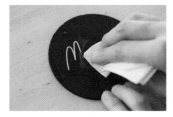

Erase your writing with a damp paper towel and try again.

Note

Thicken and fill in your downstrokes.

Shown at 50%.

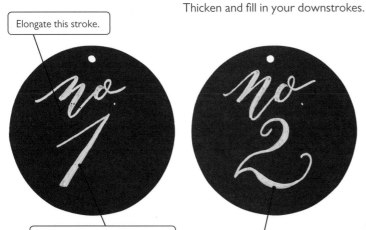

Elongate this stroke.

Create this stroke by making a thick outline and filling it in.

Create this stroke by making a thick outline and filling it in.

Write with a long, sweeping curve.

Create this stroke by making a thick outline and filling it in.

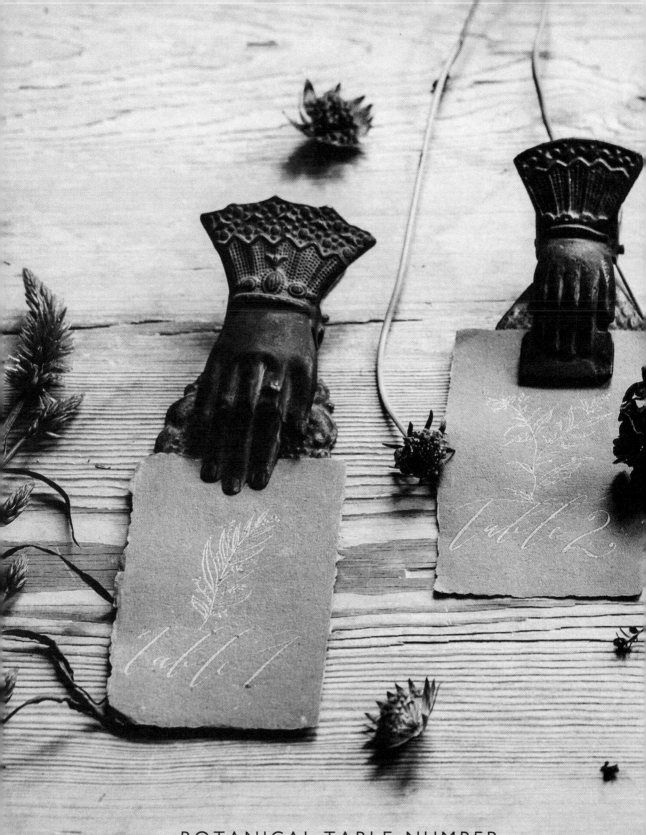

BOTANICAL TABLE-NUMBER
CARDS

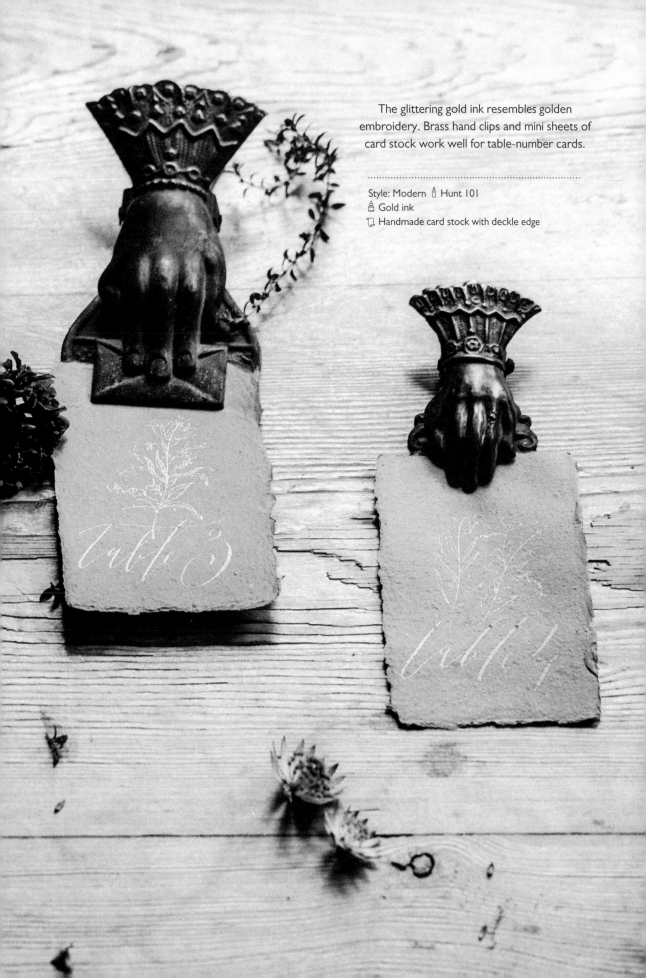

The glittering gold ink resembles golden embroidery. Brass hand clips and mini sheets of card stock work well for table-number cards.

..

Style: Modern ✒ Hunt 101
🖋 Gold ink
📄 Handmade card stock with deckle edge

LEAF ORNAMENTS

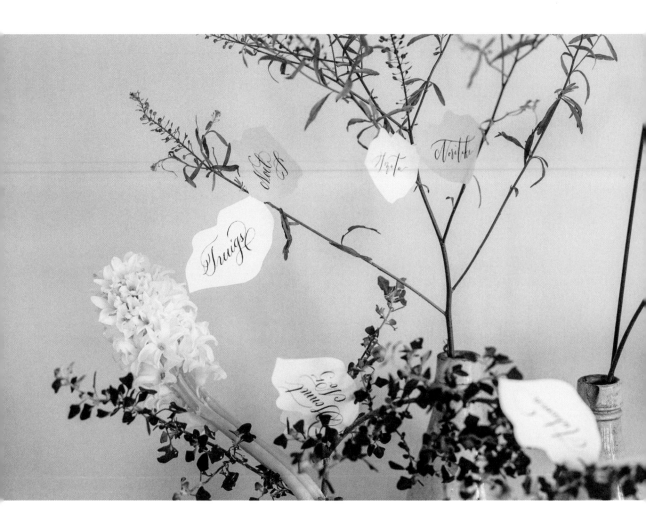

Cut sketch paper into leaf shapes and attach
them to branches, where they almost
resemble alighting butterflies. It can be fun
to write down a wish on a leaf each day.

..

Style: Classic, Modern 🖋 Hunt 101
🖌 Black ink
🗒 Sketch paper (90 gsm)

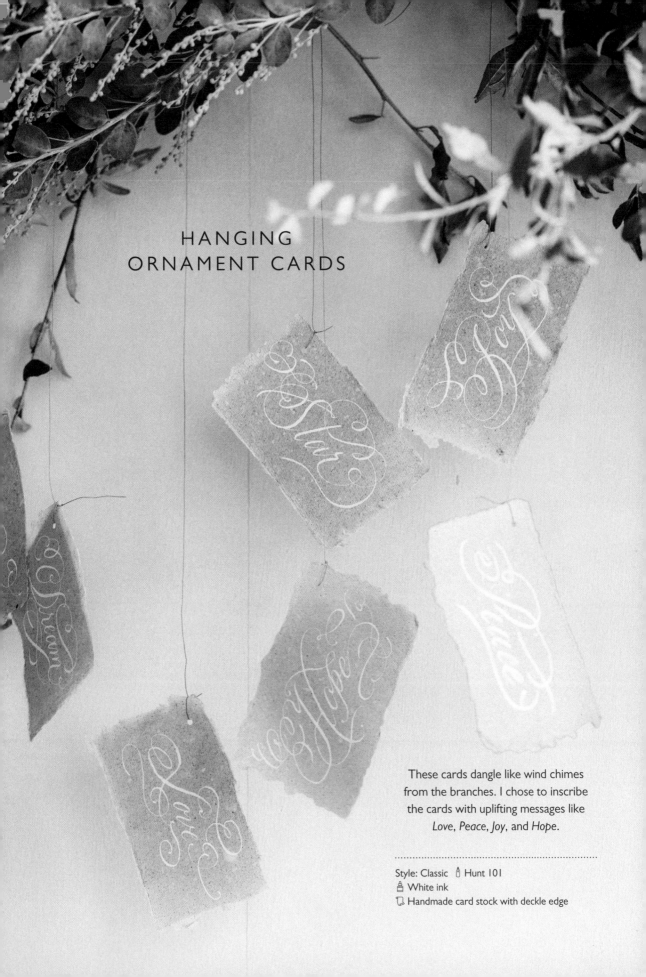

HANGING
ORNAMENT CARDS

These cards dangle like wind chimes
from the branches. I chose to inscribe
the cards with uplifting messages like
Love, *Peace*, *Joy*, and *Hope*.

Style: Classic Hunt 101
White ink
Handmade card stock with deckle edge

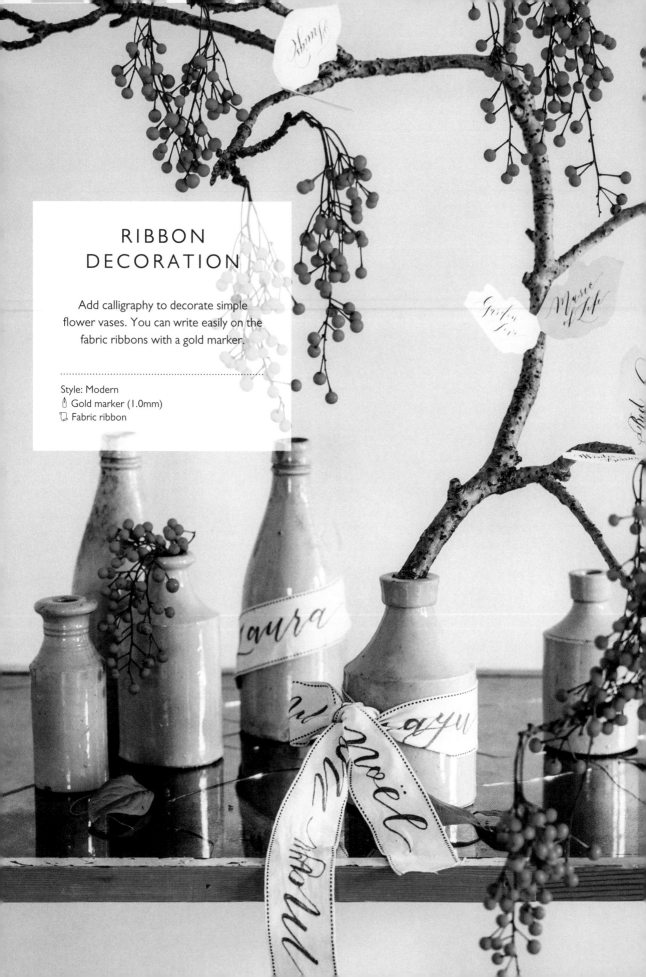

RIBBON
DECORATION

Add calligraphy to decorate simple flower vases. You can write easily on the fabric ribbons with a gold marker.

Style: Modern
Gold marker (1.0mm)
Fabric ribbon

RIBBON DECORATION

How-To

Size	1½ inches (3.5cm) wide
Words	noël
Style	Modern
Materials	🖊 Gold marker
	🎀 Fabric ribbon
	+ Scissors, object to use as a weight

Write the message

1 — Cut the ribbon to your desired length.

>

2 — Weigh down one end of the ribbon with your object to hold it in place, then begin writing in marker.

>

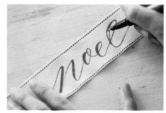

3 — Decide where you want to create the appearance of broad strokes. Draw a line around around each area to create an outline and fill the outlined areas in.

Note

Thicken and fill in your downstrokes.

Add the diaeresis last.

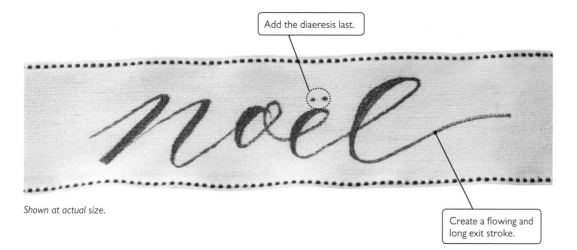

Create a flowing and long exit stroke.

Shown at actual size.

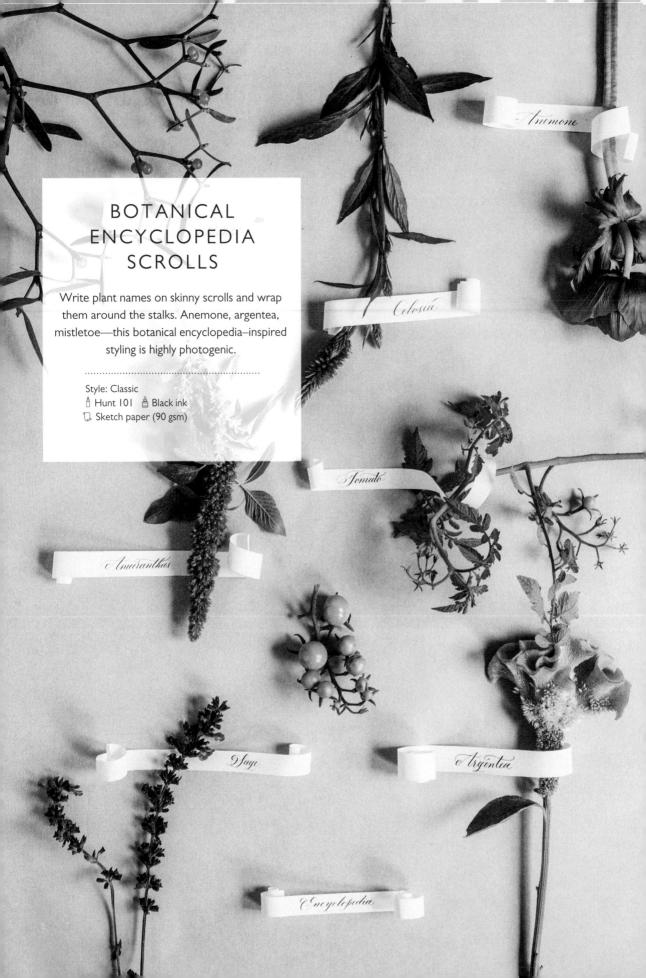

BOTANICAL ENCYCLOPEDIA SCROLLS

Write plant names on skinny scrolls and wrap them around the stalks. Anemone, argentea, mistletoe—this botanical encyclopedia–inspired styling is highly photogenic.

··

Style: Classic
✒ Hunt 101 🖋 Black ink
📄 Sketch paper (90 gsm)

Anemone

Celosia

Tomato

Amaranthus

Sage

Argentea

Encyclopedia

BOTANICAL GREETING CARDS

Even these simple cards, made by cutting two slits into a card and
inserting a flower through the slits, can shine when paired with calligraphy.
Together, they would make a wonderful gift for someone you hold dear.

..

Style: Classic 🖋 Hunt 101 🖋 Black ink
🗒 Sketch paper (90 gsm)

RIBBON-WRAPPED
ARRANGEMENT

I made this square arrangement at a workshop
collaboration with Junji Noritake, then I added a
ribbon with calligraphy to make it feel mine.

Style: Modern �散 Grosgrain ribbon
⌷ Gold marker, 1.0 mm

ORIGATA FOR FLOWERS

Origata are traditional Japanese techniques for wrapping gifts without the use
of scissors, tape, or glue. This style is called kinohana-tsutsumi. Fill the paper with
flowing calligraphy to transform the wrapping into part of the gift itself.

Style: Modern Hunt 101 Black ink
Sketch paper (90 gsm)

MINI BOUQUET WRAPPER

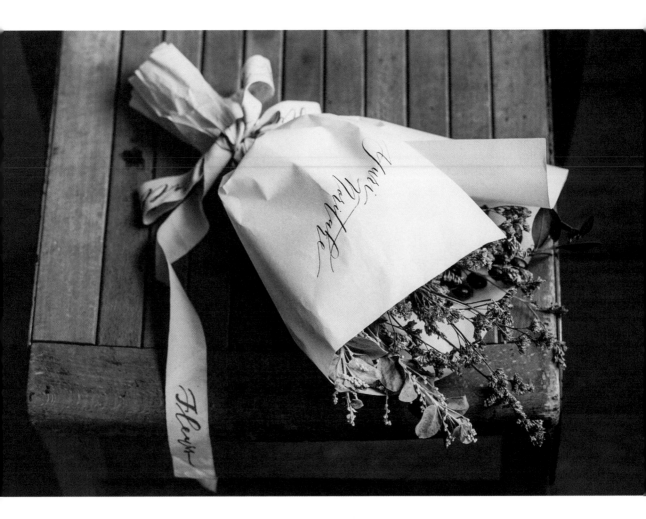

This simple design features only a name. Tisane Infusion's Yuri Noritake taught me how to put little creases into the paper at the bottom of smaller bouquets for to improve the wrapper's appearance.

...

Style: Modern ✒ Hunt 101
🖊 Black ink on paper, gold marker on ribbon
📄 Handmade washi paper

BOUQUET WRAPPER

When writing calligraphy on a bouquet wrapper, choose any words that strike you. Fill the paper with something vibrant and heartwarming, whether it be song lyrics, poetry, wishes, or anything else.

...

Style: Classic
✒ Hunt 101 🖊 Black ink
📄 Handmade washi paper

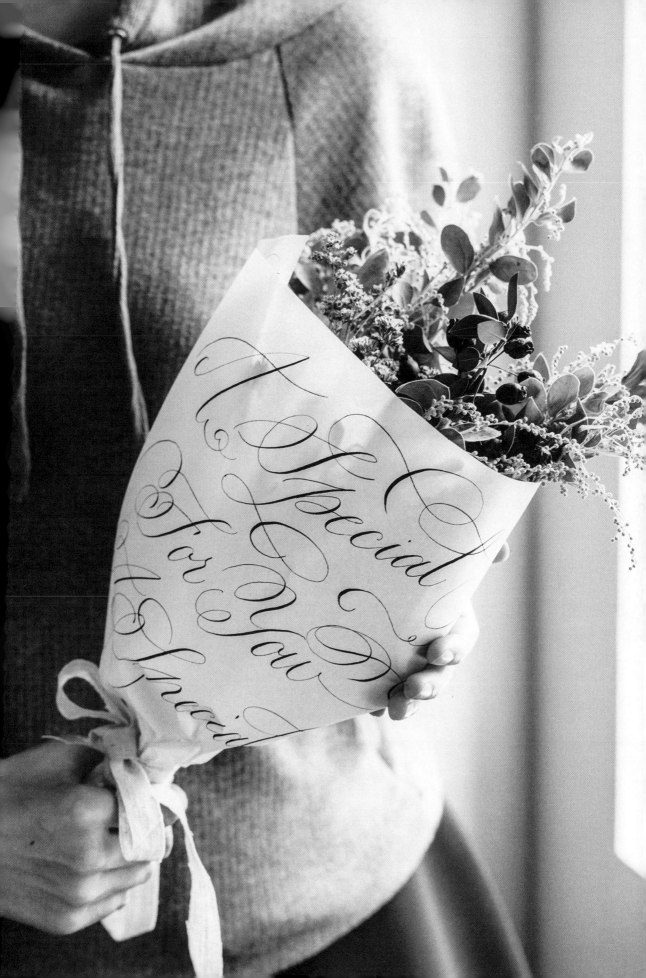

Wrappings, Papers, And Packaging

If you were going to make chocolate, what would you think about before you start? You might consider if you wanted to make it sweet or bitter. Or you might consider the look of the finished item—should it be chic French or modern American? When you set about to design a kind of packaging, you should construct your desired image in this same way.

You can't design a package without knowing what will go inside. Once you've determined the product or gift, then decide on the calligraphy style and choose your paper or other medium to match. You can add some watercolor paint or gold foil, or make gift wrap out of practice paper or even repurposed waste paper—the more you expand your ideas, the more your possibilities grow. For any project to feel complete, you must also pay attention to the small details, like little tags or labels.

Lately, more and more entrepreneurs have been starting small artisanal businesses, like third-wave coffee shops, artisanal bakeries, and pâtisseries. Calligraphy is a great fit for packaging small business products.

CHOCOLATE BAR
WRAPPER

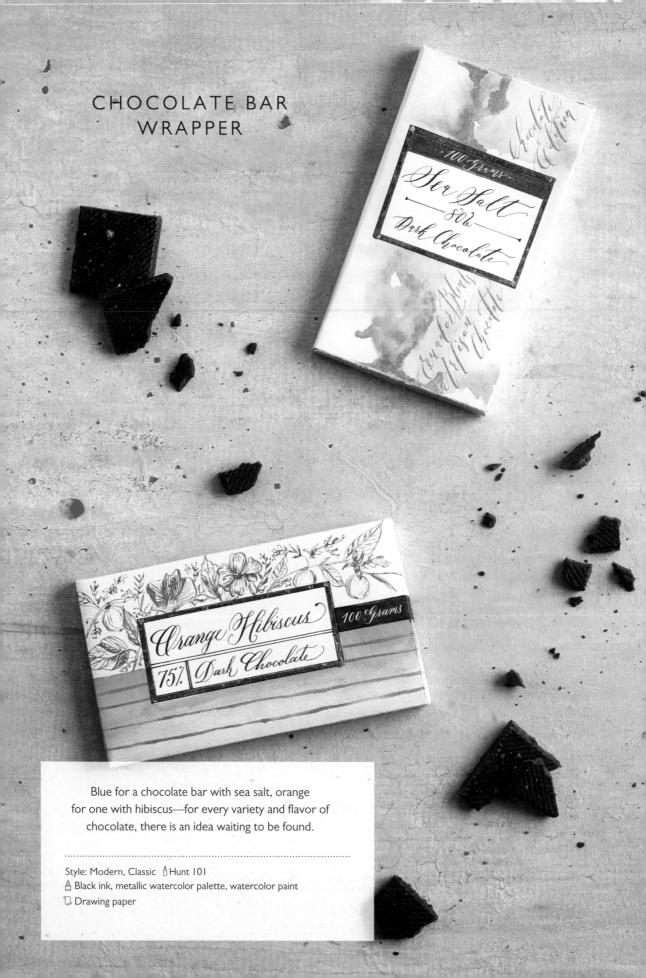

· 100 Grams ·

Sea Salt

— 80% —

Dark Chocolate

Chocolate Edition

Ecuador Beans Artisan Chocolate

Orange Hibiscus

75% *Dark Chocolate*

100 Grams

Blue for a chocolate bar with sea salt, orange
for one with hibiscus—for every variety and flavor of
chocolate, there is an idea waiting to be found.

Style: Modern, Classic ⬤ Hunt 101
🖋 Black ink, metallic watercolor palette, watercolor paint
📄 Drawing paper

CHOCOLATE BAR WRAPPER

Size	5½ x 8 inches (14 x 20.5 cm) before wrapping and 5½ x 3 inches (14 x 7.5 cm) after wrapping
Words	100 grams / Sea Salt 80% Dark Chocolate / Ecuador Blends Artisan Chocolate / Chocolate Edition
Style	Modern
Materials	✒ Hunt 101
	▤ Black ink, metallic paint palette, watercolor paint
	▱ Drawing paper
	+ Pencil, ruler, craft knife, cutting mat, water, eraser, paintbrush, double-sided tape

Crease the Paper and Create the Pencil Work

1 — Place the bar of chocolate in the center of the paper. With a pencil, mark the edges of the chocolate bar.

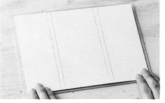

2 — Draw guidelines the width of the chocolate bar. Draw two more lines matching the thickness of the chocolate.

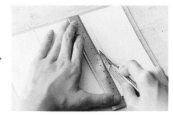

3 — Using a ruler and the blunt side of your craft knife's blade, create fold lines along the pencil guides.

Paint the Label and Ink Your Letters

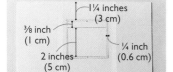

1¼ inches (3 cm)
⅜ inch (1 cm)
¼ inch (0.6 cm)
2 inches (5 cm)

4 — Using a pencil and ruler, partition your label as shown.

5 — Write the calligraphy with pencil.

6 — Mix the sky blue and purple paints and thin the mixture with water.

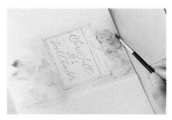

7 — Paint the outside sections of the label, keeping the colors light. Allow your colors to overlap in places to create color variations.

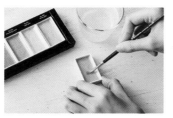

8 — Add water to your metallic gold palette— I'm using Gansai Tambi Blue Gold—and mix with a paintbrush.

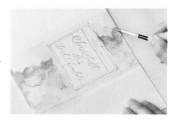

9 — Add splashes of gold paint on top of what you painted in step 7, staying clear of the areas where your calligraphy will go.

10 Using a paintbrush, apply the gold paint to your nib.

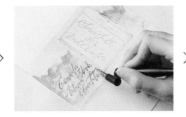

11 Using your pencil work as a guide, write your calligraphy with pen and ink.

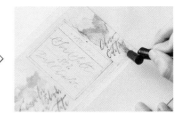

12 Don't forget the calligraphy above the label.

Paint Inside the Label and Ink Your Letters

13 Mix together black and gold on your palette—I'm using Gansai Tambi White Gold for this step.

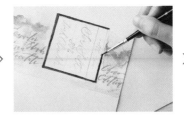

14 Paint the label's border.

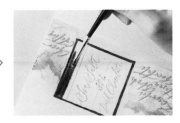

15 Paint the label's top frame with the same color.

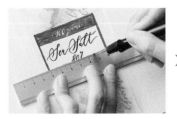

16 Using black ink and your pen, ink over the text inside the label.

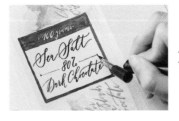

17 Apply gold ink—White Gold in my example— to your nib.

18 Write 100 grams over the gray background.

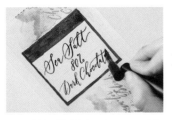

19 Using a ruler and your pen, add a thin line across the center of the label in black ink.

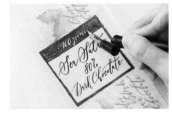

20 Add a triangle detail at each end of the line.

21 Erase the pencil work. You've created the wrapper.

Wrap the Chocolate

22 Turn the paper face down and place the bar in the center. Apply double-sided tape to the underside of one edge.

23 Fold the paper around the chocolate bar, leaving the edge with the tape.

24 Fold the remaining edge closed so that the double-sided tape will hold both flaps in place.

Note

Elongate your entrance and exit strokes
for a chic effect.

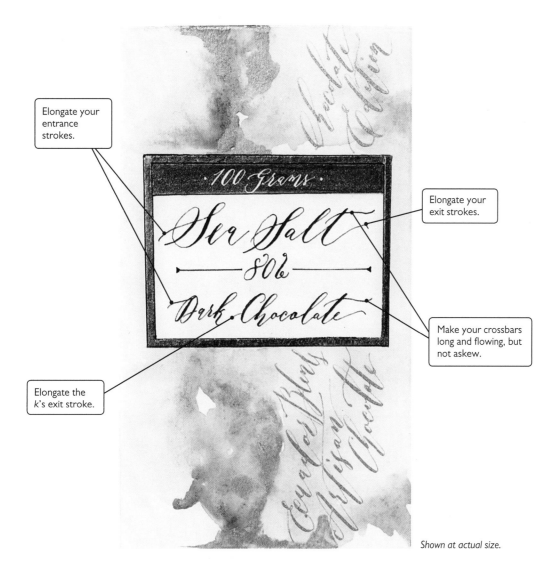

Elongate your
entrance
strokes.

Elongate your
exit strokes.

Make your crossbars
long and flowing, but
not askew.

Elongate the
k's exit stroke.

Shown at actual size.

BONBON WRAPPER

When I was young, my parents would buy me bonbons. I kept a collection of their many beautiful wrappers. Those happy memories inspired me to recreate those wrappers in my own style.

Style: Classic ♙ Hunt 101

🖋 White ink 🗋 Onionskin

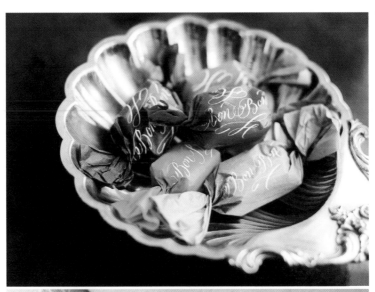

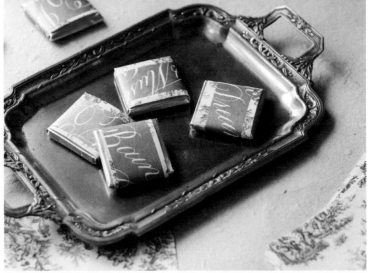

I wrapped bands of gold paper, printed with calligraphy, around blue and white chinoiserie-styled paper. This gorgeous packaging stands shoulder-to-shoulder with that of premium chocolates.

MINI CHOCOLATE WRAPPER

Style: Classic ♙ Hunt 101, then digitized 🖋 Black ink, then digitized

🗋 Thin wrapping paper

BONBON WRAPPER

Size	7 x 7 inches (17.5 x 17.5 cm) before wrapping, 5¾ inches (14.5 cm) long and 1½–2 inches (4–5 cm) tall after wrapping
Words	Bon Bon
Style	Classic
Materials	⬤ Hunt 101
	⬤ White ink
	⬤ Onionskin
+	Sheets of paper to lay underneath for cushioning, pencil, eraser, small mixing container, water, bonbon

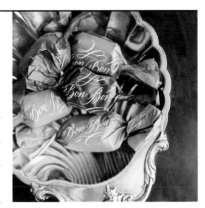

Create the Pencil Work

1 Place the bonbon in the center. Because the onionskin is thin, place another paper underneath.

2 Place dots marking the four corners of the bonbon. This will be visible outside of the wrapper.

3 In the space created by those guide marks, write *Bon Bon* with flourishes using your pencil.

Ink the Calligraphy

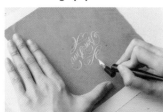

4 Write over your pencil work with white ink. Holding the thin paper firmly in place. To mix the white ink, refer to the Christmas card on page 42.

5 Once the ink has completely dried, erase your pencil work. Remember to hold the thin onionskin firmly in place as you erase.

6 This is the finished paper.

Wrap the Bonbon

7 Turn your paper over and place the bonbon on the paper.

8 Starting at the bottom, roll the paper around the bonbon.

9 Once you have rolled the paper, pinch the open ends and straighten out its shape.

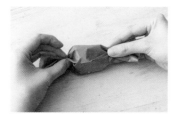

10 Gently twist both ends of the paper.

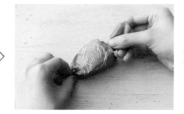

11 Turn the wrapped bonbon over and tidy up the paper's shape.

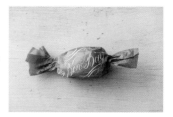

12 This is the finished wrapper.

Using Darker Paper

1 Mark the four guide points with your nib and white ink instead of a pencil.

2 Because pencil lines would be too hard to see, proceed straight into writing your calligraphy with ink.

3 When writing the upper flourishes, rotate all the papers upside down, including the bottom sheet.

Note

Add your ornamentations last so that you can maintain a good balance to the design.

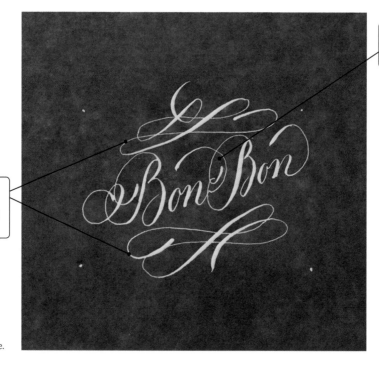

Cross the flourishes of the first *n* and the second *B*.

Write the ornamentations after completing the letters.

Shown at actual size.

BOOK COVER

Have you considered making covers for your favorite books? With a simple watercolor drawing and the title in calligraphy, a handmade cover will be sure to bring you closer to your works.

Style: Modern Nikko G
Black ink, watercolor paint
Sketch paper (90 gsm)

JAR LABELS

For these jars of olives and capers, I made handwritten labels on handmade paper. The illustrations enhance the modern calligraphy.

·······································

Style: Modern Nikko G
Black ink, watercolor paint
Handmade paper with deckle edge

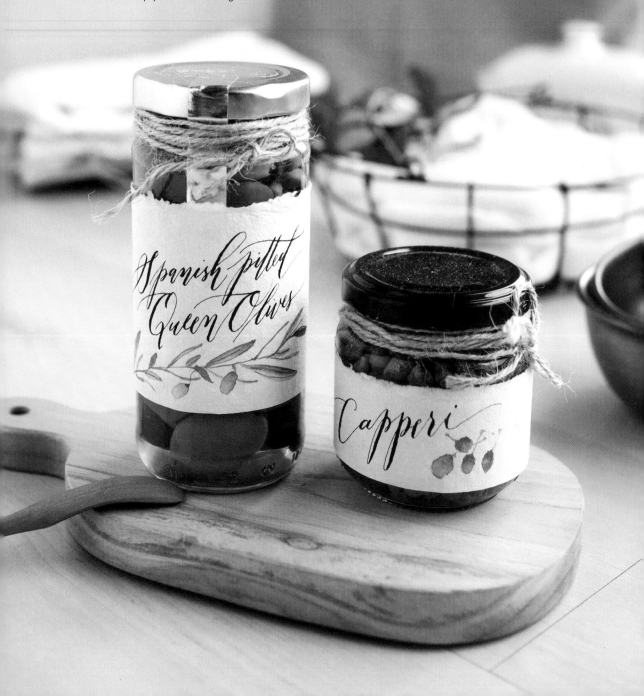

BOTTLE LABEL

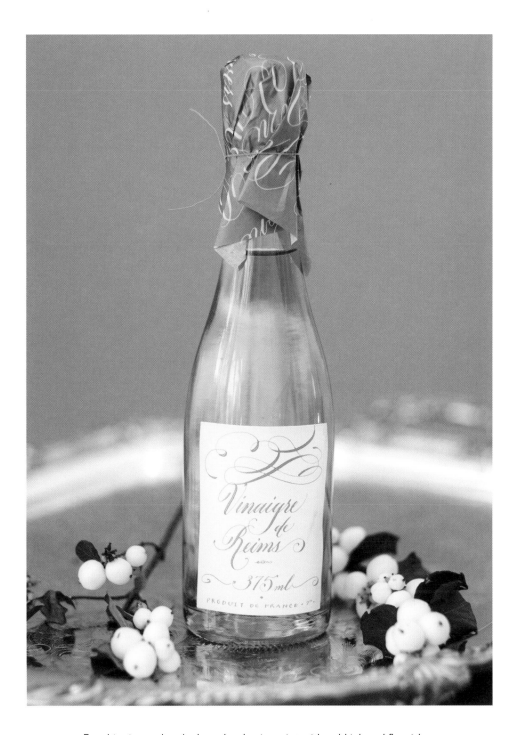

For this vinegar bottle, I used a classic script with gold ink and flourishes.
This style of label would also work well on a wine bottle.

Style: Classic Hunt 101 Gold ink
Sketch paper (90 gsm)

WRAPPING PAPER

Try combining different inks, papers, and scripts to find starting points for your designs—for example, white ink, gold paper, and a classic script.

Style: Classic, Modern Hunt 101
Black ink, white ink, white chalk marker
Sketch & drawing paper, thin wrapping paper, kraft paper

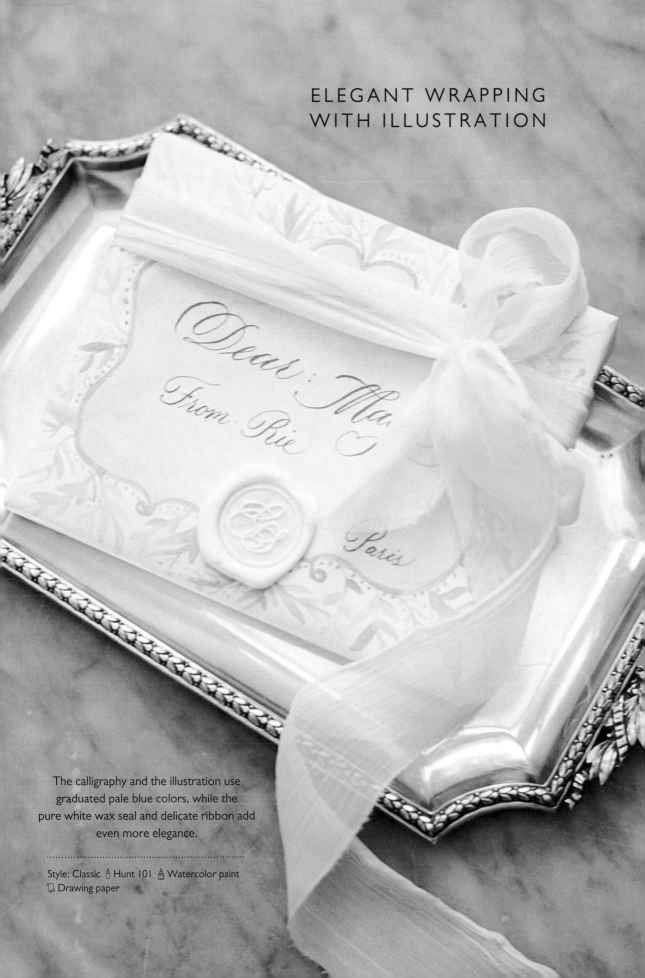

The calligraphy and the illustration use
graduated pale blue colors, while the
pure white wax seal and delicate ribbon add
even more elegance.

Style: Classic ✍ Hunt 101 🖌 Watercolor paint
📄 Drawing paper

Halloween Styling Ideas

PUMPKIN FAUX CALLIGRAPHY

Nothing says Halloween like a pumpkin. Instead of carving a jack-o'-lantern, I sketched the word "Boo" with a white chalk marker.

Style: Modern
White chalk marker
Pumpkin

HALLOWEEN TOPPER

Try writing Halloween-themed words or phrases on small flags and attach them to decorative straws.

Style: Classic Hunt 101
Gold ink
Black drawing paper

Christmas Styling Ideas

CHRISTMAS GIFT BOX

Take a plain kraft paper canister and decorate
them with your own calligraphy and illustrations.
Ribbons and berries make cute additions.

..

Style: Classic Hunt 101
White ink
Kraft paper container

CALLIGRAPHY RIBBON

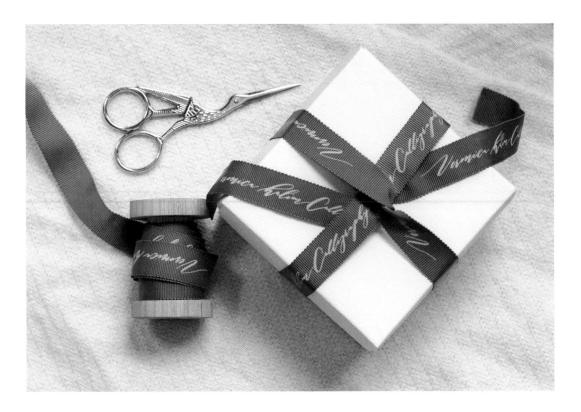

Having custom-made ribbon of your very own is wonderful. I digitize
my handwritten calligraphy and have a printing service create the ribbon.

..

Style: Modern ⬩ Hunt 101, then digitized
⬩ Black ink, then digitized ⬩ Grosgrain ribbon

HOW TO SCAN AND DIGITIZE CALLIGRAPHY

1 Write your source calligraphy using black ink on white paper.

2 Using a scanner, scan in your source calligraphy at 1200 dpi and save as a JPEG image file.

3 Using an image and photo editing software, convert your JPEG file into an EPS file.

4 Open the EPS file in a vector graphics editing software, and trace your calligraphy to
create a vector file.

5 Send your digital data to a custom printer and have it printed onto ribbon, fabric, or more.

CALLIGRAPHY RIBBON

How-To

Size	Ribbon: ¾ inch (2 cm) wide
Words	abcdefghijklmnopqrstuvwxyz
Style	Modern
Materials	⬧ Hunt 101
	⬧ Black ink
	⬧ Smooth copy paper, custom-printed grosgrain ribbon
	+ Pencil, ruler, eraser, scanner, software for digitizing image

Write the Message

1 You will write on white letter-size or A4 paper. In pencil, draw your horizontal guidelines spaced about ½ inch (1cm) apart.

2 Following your guidelines, write the alphabet in ink. You may first write the letters in pencil, if you like.

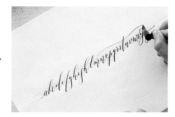

3 Write the letters from *a* to *z*, then cross the *t* at the end.

4 This is the finished page. After the ink has completely dried, erase your pencil work.

5 The page is ready for scanning.

Print the Ribbon

6 Using the guide on page 116, digitize your calligraphy and print your ribbon.

Note

Try to keep the thin strokes of each letter equally thin and the thick strokes equally thick.

> Write the *t*'s crossbar last. The crossbar should be long and dramatic.

abcdefghijklmnopqrstuvwxyz

Shown at 70%.

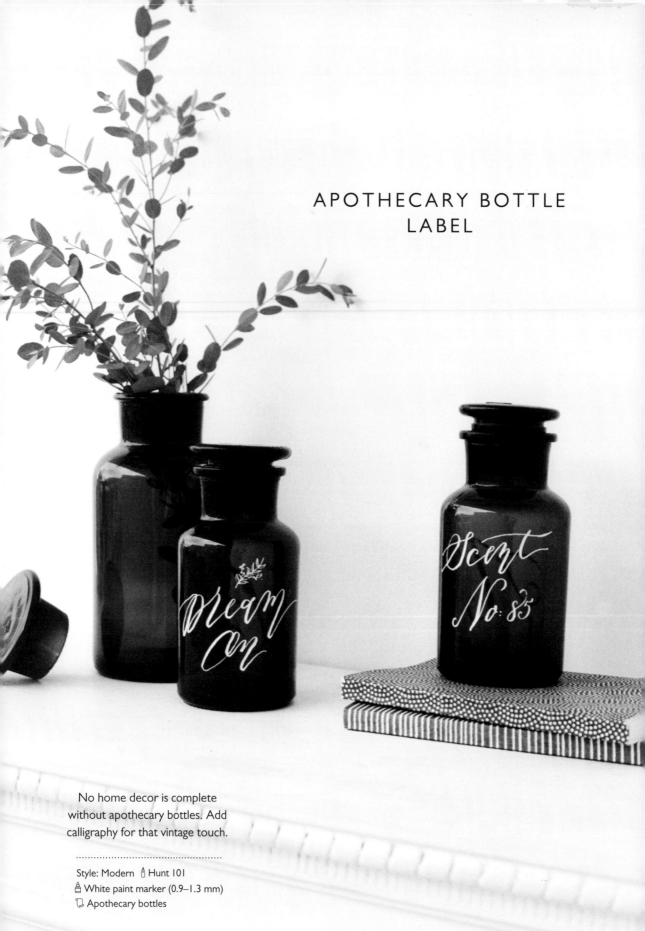

APOTHECARY BOTTLE LABEL

Dream On

Scent No: 85

No home decor is complete without apothecary bottles. Add calligraphy for that vintage touch.

...

Style: Modern ⬆ Hunt 101
🖊 White paint marker (0.9–1.3 mm)
🫙 Apothecary bottles

APOTHECARY BOTTLE LABEL

| | How-To |

Size	Bottle: 2½ inches (6.5 cm) in diameter, 5½ inches (14 cm) tall
Words	Scent No.85
Style	Modern
Materials	🖊 Hunt 101
	🖍 White paint marker
	🍶 Apothecary bottle

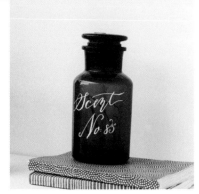

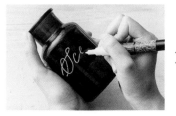

1 Grip the bottle firmly with one hand and write your letters with a white marker using the other.

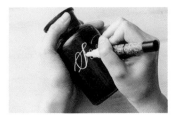

2 Once you've finished writing, thicken the stokes as desired.

3 Write the lower *No.85*, then thicken the strokes as desired.

Note

Go back over your downstrokes to thicken them.

Scent

Make the exit stroke long and flowing.

Elongate this downstroke.

No. 85

This stroke should be long and directed upward. Leave the top of the *8* open rather than closing the loop.

Shown at 55%.

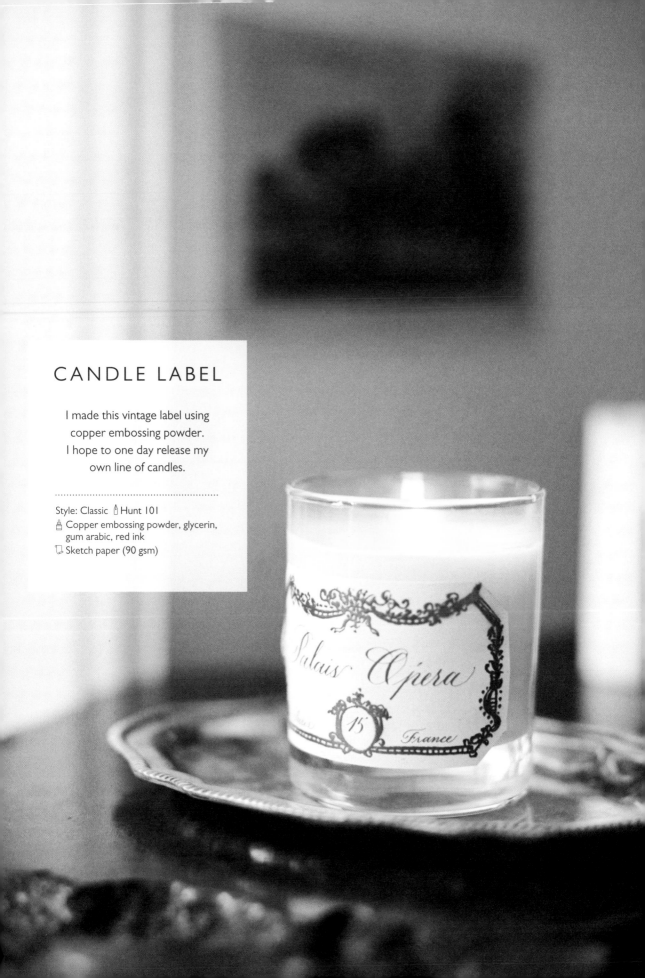

CANDLE LABEL

I made this vintage label using copper embossing powder. I hope to one day release my own line of candles.

..

Style: Classic 🕯 Hunt 101
🖋 Copper embossing powder, glycerin, gum arabic, red ink
🗒 Sketch paper (90 gsm)

TEA PACKETS

This idea came to me when I was drinking spiced tea while writing cards and letters. These packets of tea, made to look like sachets, work well as ornaments or as gifts.

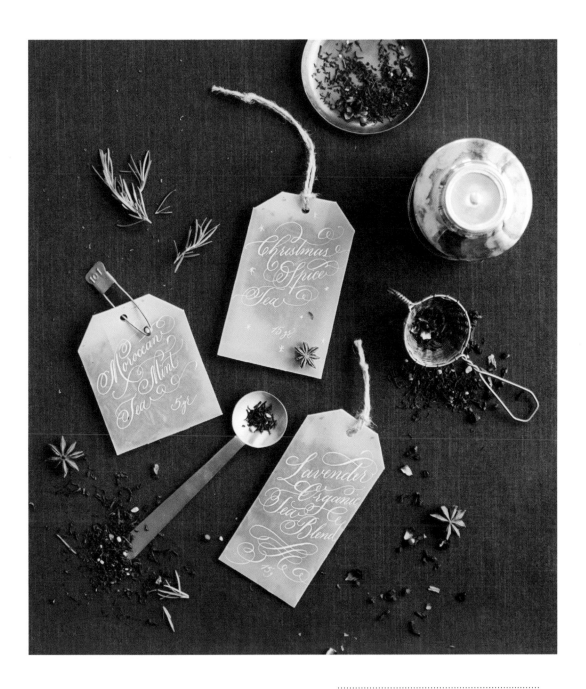

Style: Classic 🖋 Hunt 101
🖋 White ink
📄 Tracing paper

CHAPTER

6

—

The World of Weddings

Calligraphy is closely tied to many items commonly associated with weddings, from invitations to place cards and table runners. The wedding invitation plays a key role as being the first communication of the wedding's theme and mood to the guests. Even on its own, a high-quality card written with beautiful calligraphy will spread wedding cheer and is sure to delight the recipient.

When I take on a job for a wedding, I first meet with the couple and spend plenty of time asking them many questions, including what they envision as their ideal wedding and their taste in colors. I make mood boards to help decide the overall direction my designs will take. For example, a classic script might suit a couple who likes elegant white weddings with hydrangea and lilies. On the day of the ceremony, when my calligraphy items are added to the venue's decorations, and perfectly match the scene I had envisioned, I can't help but smile. In that moment, I feel happiness.

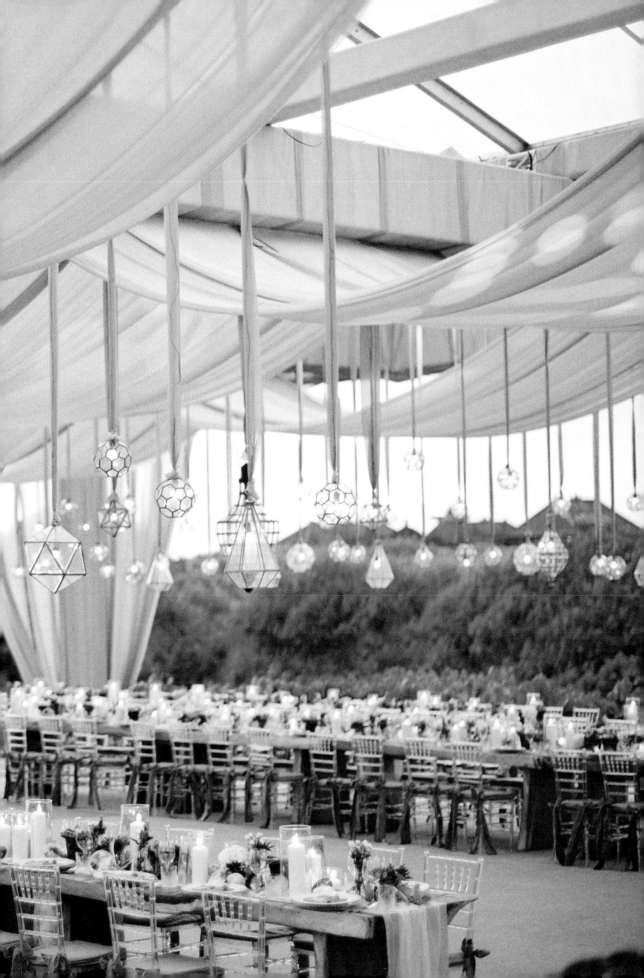

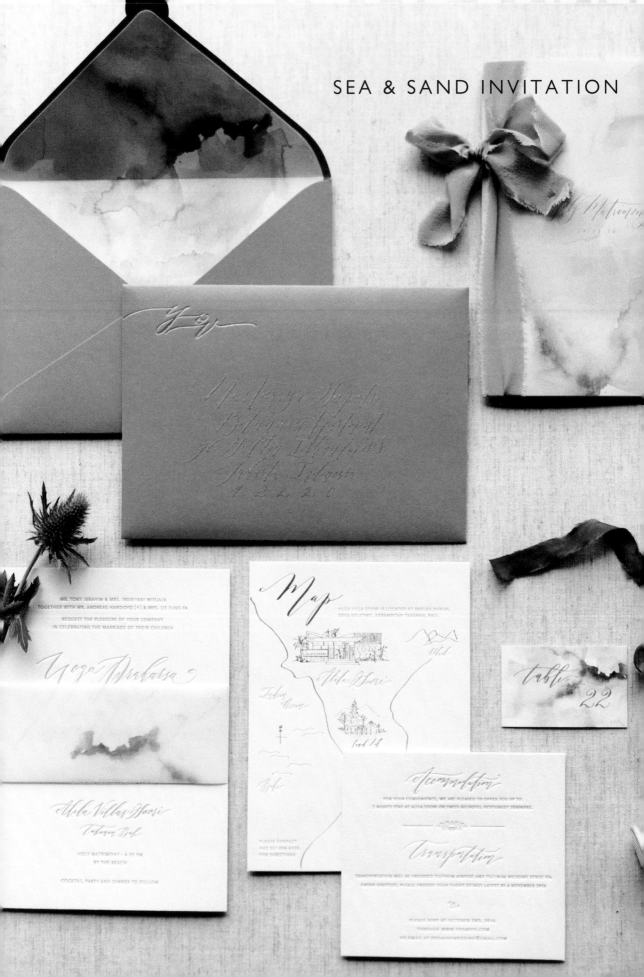

1 Envelope
2 Envelope with liner paper
3 Invitation card
4 Illustrated map
5 Welcome booklet tied with fabric ribbon
6 Accommodation and transportation card
7 Bellyband

This wedding was held on the island of Bali. I designed the colors of the invitation to reference the island scenery with ocean blue and khaki colors for the sea and sand. The indigo blue watercolor for the envelope liner and bellyband evoke a romantic seashore with waves lapping at your feet. The long, carefree strokes of the modern-style calligraphy communicate a free-spirited state of mind.

..

Style: Modern ✒ Hunt 101
Black ink, then digitized for print, letterpress, gold foil; names and addresses: gold ink
Envelope: Fine Italian paper (250 gsm)
Cards: Cotton paper stock (400 gsm)
Envelope liner: Tracing paper

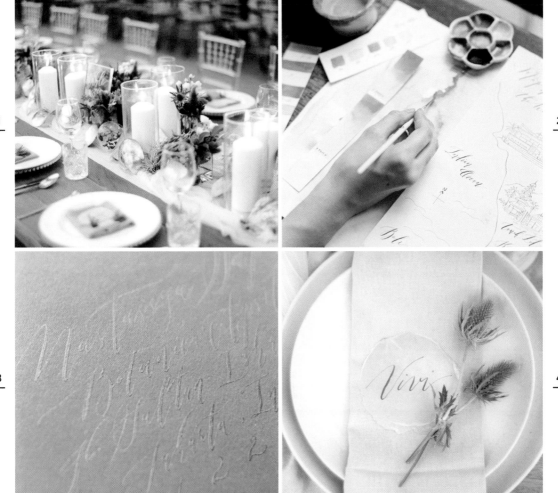

1 The guest tables were also decorated with ocean blue and green accents for a natural look.
2 It's important to create color swatches to prevent straying from the wedding colors.
3 The envelopes represent a blue sky, with the gold ink glittering like the Bali sun.
4 For the guests' place cards, the ocean theme led me to choose capiz place cards (page 140).

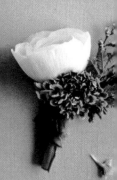

1 Envelope
2 Invitation card
3 Dinner card and envelope
4 Event details card (white) and envelope (gray)
5 Exchange of vows card
6 Accommodation and transportation card

The theme for this invitation suite, both in color and design, came from two of the bride's favorite things: wineries with expansive vineyards and French vintage chandeliers. I chose a red wine burgundy for the outermost envelope, and romantic gray and pink for the smaller envelopes. The use of gold foil throughout provided elegance and unified the design.

...

Style: Modern 🖋 Hunt 101
🖊 Black ink, then digitized for print, letterpress, gold foil; gold ink for the addresses
📄 Fine Italian paper (250 gsm for the envelopes; 360 gsm for the cards)

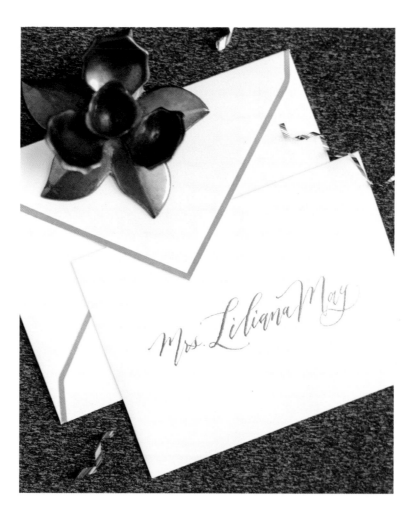

HAND-FOILED ENVELOPE

By employing gold foil, you can turn plain envelopes into something luxurious. The letters rise slightly from the paper, as if embossed, for a magical effect.

...

Style: Modern 🖋 Nikko G
🖊 Gold foil, gilding size 📄 Fine Italian paper envelope

HAND-FOILED ENVELOPE

Size	4¾ x 4¾ inches (12 x 12 cm)
Words	Mrs. Liliana May, Ms. Eri Hoshi
Style	Modern
Materials	◊ Nikko G
	▤ Gold foil, gilding size
	▯ Fine Italian paper envelope
	+ Ruler, pencil, scrap paper for testing gilding size, water, eraser

Create the Pencil Work

1 In the center of the envelope, draw two guidelines spaced ¼ inch (0.7 cm) apart.

2 Write the names in pencil.

Write with Gilding Size

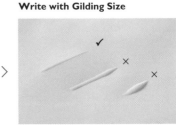

3 Apply the size to your nib and make test strokes to ensure the size flows evenly. Adjust your pressure as needed. Take care not to lay on the size too thickly.

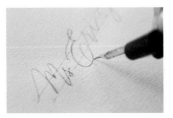

4 Trace over your pencil work with the gilding size.

5 If you're having trouble getting the size onto the paper on your upstrokes, you can use only downstrokes instead.

6 This is the envelope with the size applied. Let it dry for 15 to 20 minutes. It will remain tacky.

Apply the Gold Foil

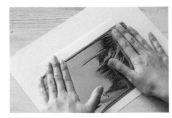

7 After you've finished writing, be sure to wash your nib clean before the size hardens.

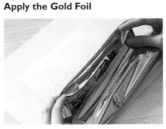

8 Place the gold foil over the envelope.

9 Using your hands, flatten the foil so that there are no wrinkles.

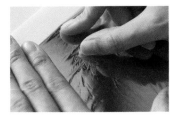

10 — Gently rub a fingernail over the gold foil to transfer the foil to the paper.

11 — You should see impressions of your writing appear on the foil.

12 — Slowly peel away the foil.

13 — The foil has been pasted onto writing.

14 — Erase your pencil work.

15 — This is the finished envelope.

Note

Make the uppercase letters large, and the lowercase letters small.
Vary the tops and bottoms of your letters to create a visual rhythm.

Elongate the entrance stroke.

Elongate the exit stroke.

Shown at actual size.

PEONY & LAPIN
INVITATION

Florence

Timothy

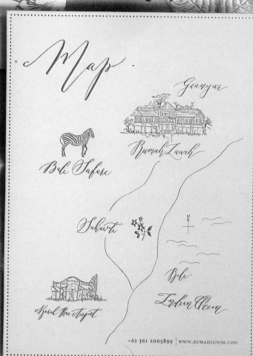

hello

YOUR PRESENCE MEANS ALOT TO US.
WE APPRECIATE YOU COMING ALL
THE WAY HERE FOR OUR WEDDING

SHOULD YOU HAVE ANY QUESTIONS
OR NEEDS, PLEASE KINDLY CONTACT
OUR WEDDING COORDINATOR

RIA +62 812 8998 7341 OR
CHANDRA +62 817 757 429

FOR MORE INFORMATION PLEASE
VISIT OUR WEDDING WEBSITE :
WWW.THEKNOT.COM/US/TIMOTHYFLORENCE
PASSWORD:51116

Lots of Love,
Timothy & Florence

MR. SOEGIARTO AMIN & MRS. SUMIATI SUMARDI
Together With
MR. HANTHONY HALIM & MRS. FEROLINE KURNIAWAN
REQUEST THE HONOR OF YOUR PRESENCE AS WE WITNESS

Timothy Christian Minardi
AND
Florence Halim

EXCHANGE THEIR VOWS ON
SATURDAY, 5TH OF NOVEMBER 2016
KALYANA CHAPEL AT 4 PM

Rumah Luwih
JL. OF IDA BAGUS MANTRA, KM19.9,
LEBIH, KEC. GIANYAR,
BALI, INDONESIA

COCKTAIL PARTY AT 5.30 PM
DINNER AND DANCING TO FOLLOW AT 6.30 PM

DRESS CODE: Formal, Shades of Ne... Comfortable Shoes

Map

Gianyar

Bali Safari

Rumah Luwih

Sababai

Bali
Zuban Ulun

...

+62 361 2005899 | WWW.RUMAHLUWIH.COM

1 Envelope
2 Invitation card
3 Map card
4 Welcome card
5 Bride and groom
 name cards

The theme for this invitation suite featured peonies and hares. I used peonies (one of the bride's favorite flowers) for the envelope and had it printed with gold foil. The effect was luxurious. I embossed the peonies on the invitation card for a more elegant look. The monogram featuring two hares became the wedding's logo and was heavily featured in the wedding decorations as well.

Style: Classic, Modern 🖋 Hunt 101

🖊 Black ink, then digitized for print, debossing, embossing, and rose gold foil; gold ink for name cards

📄 Fine Italian paper (360 gsm)

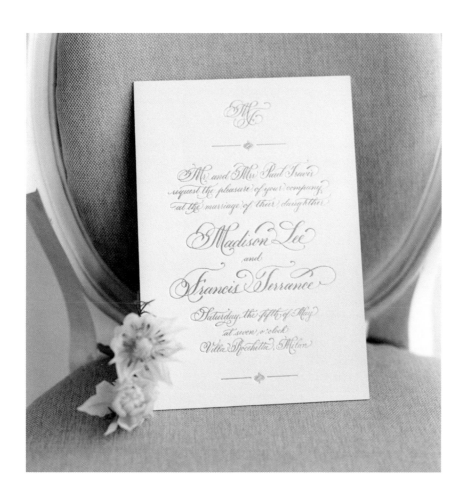

CLASSIC INVITATION

For these pieces, I added plenty of flourishes to bring out the calligraphy's inherent beauty. The suite was printed using rose gold foil for its elegant color.

Style: Classic 🖋 Hunt 101

🖊 Black ink, then digitized for print and rose gold foil

📄 Fancy cotton paper with board backing

CLASSIC ENVELOPE

This Italian-made navy blue envelope features a flourished,
classic script written in white. I really love this style.

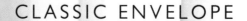

Style: Classic ✒ Hunt 101
🖋 White ink
📄 Fine Italian paper

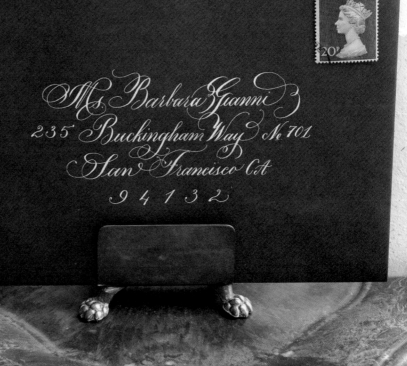

ROSETTE OLIVE INVITATION

This design was inspired by Jasper Conran's
Chinoiserie Green dinnerware. A silk ribbon
provides the finishing touch.

Style: Modern Hunt 101

Card: black ink, then digitized for print
Envelope: white ink

Card: fine Italian paper (360 gsm)
Envelope: fine Italian paper (270 gsm)

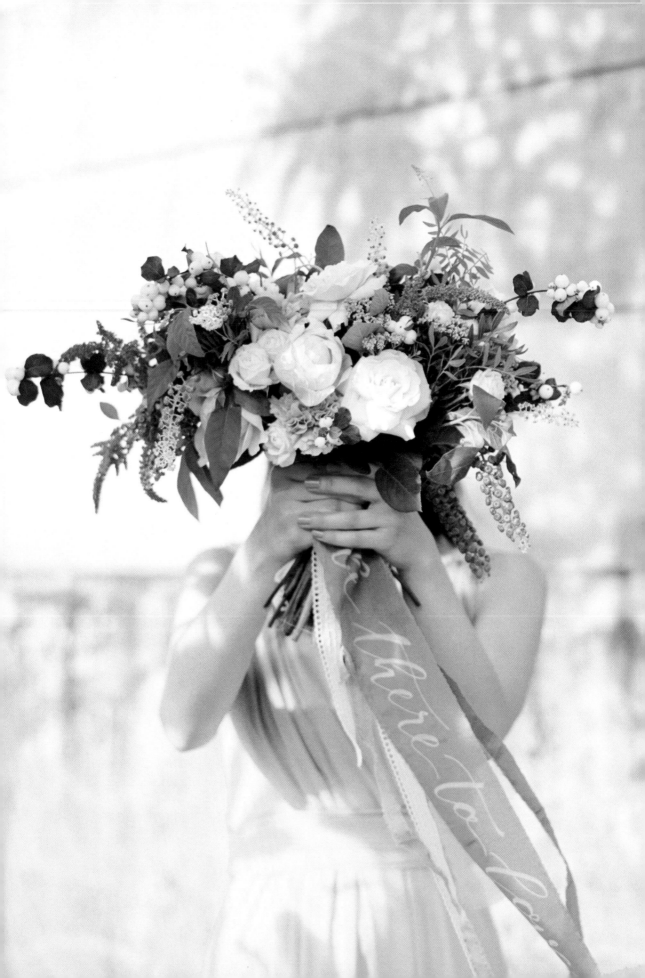

FABRIC RIBBON
CALLIGRAPHY

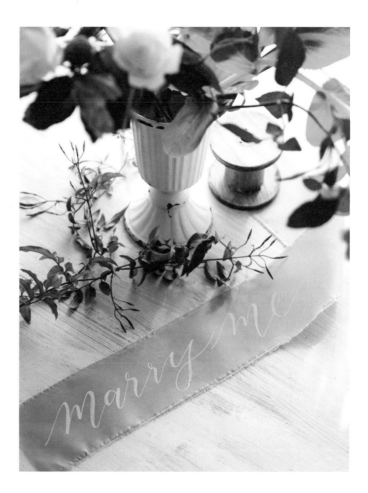

Fabric ribbons are a perfect complement to the romance of a wedding. Being able to choose the cloth to match the color to the wedding's theme is nice, too. Wrap a ribbon with a special message around a bouquet to create something memorable.

..

Style: Modern ⚱ White chalk marker
🗋 Chiffon silk fabric ribbon

FABRIC RIBBON CALLIGRAPHY

How-To

Size	3¼ inches (8 cm) wide
Words	marry me
Style	Modern
Materials	🦡 Chiffon silk fabric ribbon

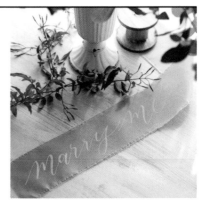

For the hair spray method	🖊 White chalk marker	
	+ Ruler, scissors, hair spray, newspaper	
For the water method	🖊 Oil-based paint marker	
	+ Ruler, scissors, water, cutting mat	

Make the ribbon

1 Using a ruler and a pair of scissors, make a cut roughly 3¼ inches (8 cm) long, measuring from in from the long edge of the fabric. This is the width of the ribbon.

2 Extend the cut a little bit more.

3 Pull apart the fabric at the cut to make your ribbon. It can be any length you want, but I suggest at least 7 feet to 8 feet long

The Hairspray Method

4 Place the ribbon on top of some newspaper and spray the ribbon with hairspray. When the hairspray dries, the ribbon will stiffen and become easier to write on.

5 Holding the ribbon flat with one hand, write your calligraphy using a chalk marker.

6 Go back over the strokes you wish to thicken.

The Water Method

4 Submerge the ribbon in water.

5 Spread the ribbon flat on top of a cutting mat.

6 Before the ribbon dries, hold it flat with one hand and write your calligraphy using an oil-based marker.

Note

Go back over your downstrokes to thicken them.

Write the first letter of each word a little larger to accentuate it.

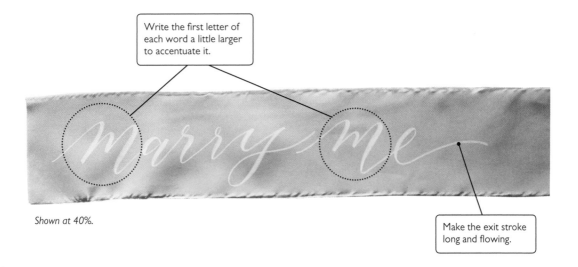

Shown at 40%.

Make the exit stroke long and flowing.

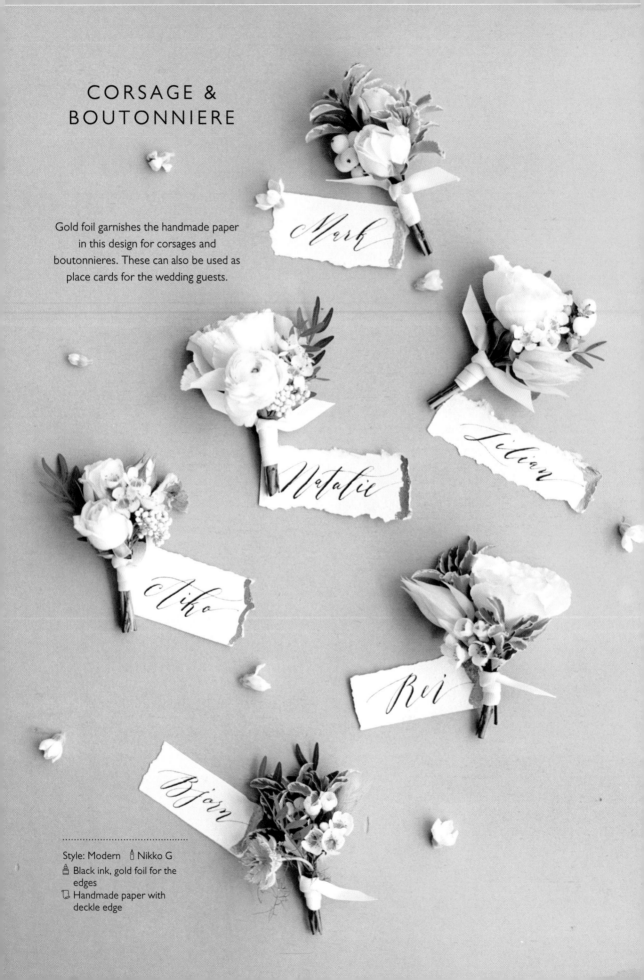

CORSAGE &
BOUTONNIERE

Gold foil garnishes the handmade paper in this design for corsages and boutonnieres. These can also be used as place cards for the wedding guests.

Style: Modern 🖋 Nikko G
🖋 Black ink, gold foil for the edges
📄 Handmade paper with deckle edge

ACRYLIC TABLE-NUMBER CARDS

These table-number cards are written with white marker on acrylic sheets.
Experiment with layering the transparent sheets over other objects like leaves.
The versatility of this design opens up many fun possibilities.

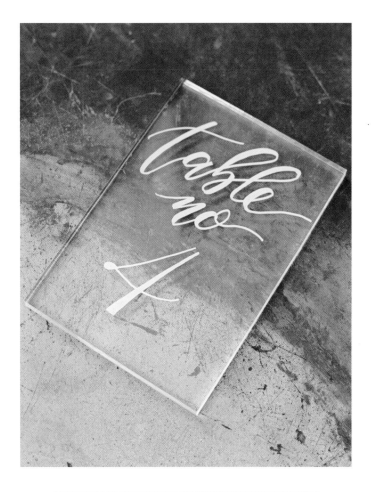

Style: Modern ⬙ N/A
🖊 White paint marker (0.9–1.3 mm)
🗋 Acrylic sheets

CAPIZ PLACE CARDS

Made from capiz shells, these place cards sparkle in the light. Guests can even take home the personalized decorations as party favors.

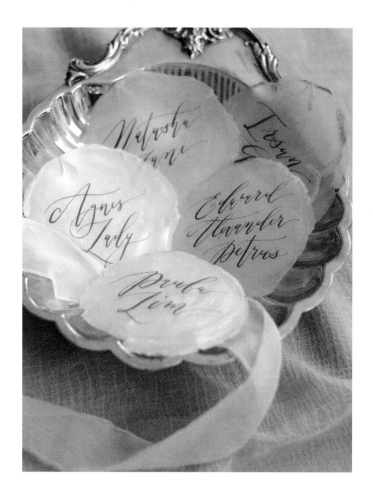

..

Style: Modern 🖊 Hunt 101
🖋 Custom-made gray ink
🐚 Capiz shell

CAPIZ PLACE CARDS

How-To

Size	Each approximately 4–4½ inches (10–11 cm) in diameter
Words	Junko
Style	Modern
Materials	⌖ Hunt 101
	🖋 Black ink, white ink
	🐚 Capiz shell
	+ Small mixing container, dropper, paintbrush

1 Put white ink into a small mixing container and add several drops of black ink.

>

2 Mix the two inks with a paintbrush to create gray ink.

>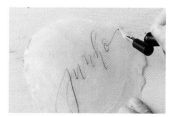

3 Write your calligraphy with the gray ink. The shells are hard—and the surface is not always smooth. Choose less fragile nibs such as Hunt 101 or Nikko G. You'll want to use pressure on your downstrokes and write at a lower angle.

Note

Extend your entrance and exit strokes to the edges of the shell to convey an expansive feel.

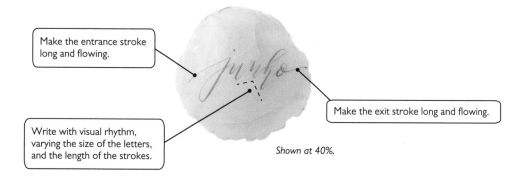

Make the entrance stroke long and flowing.

Make the exit stroke long and flowing.

Write with visual rhythm, varying the size of the letters, and the length of the strokes.

Shown at 40%.

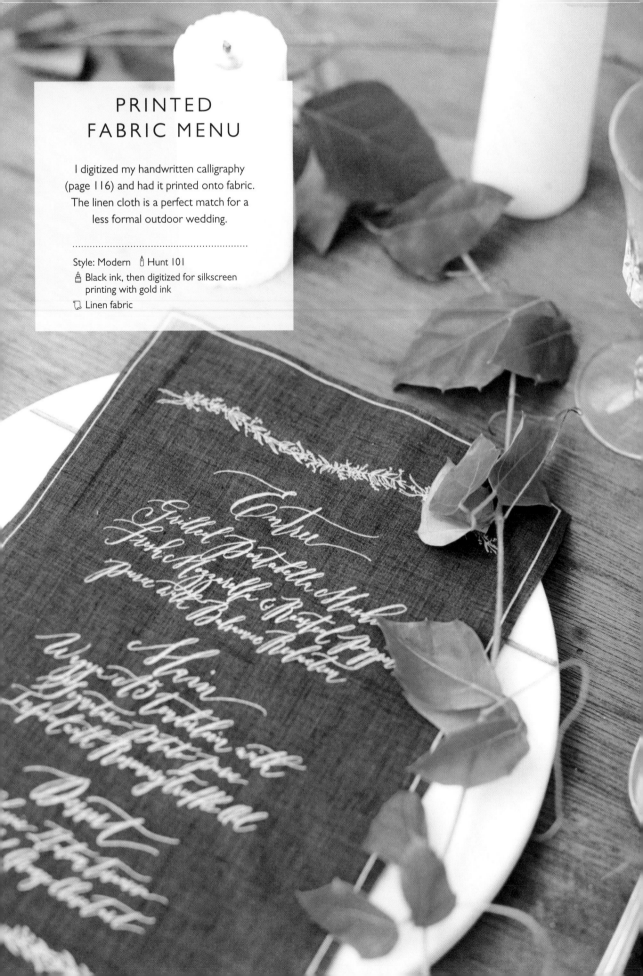

PRINTED FABRIC MENU

I digitized my handwritten calligraphy (page 116) and had it printed onto fabric. The linen cloth is a perfect match for a less formal outdoor wedding.

..

Style: Modern Hunt 101

Black ink, then digitized for silkscreen printing with gold ink

Linen fabric

CAKE TOPPER

Cake toppers are a popular focus of attention at weddings. The couple's names or a favorite phrase can be digitized (page 116) and given to someone with a laser cutter.

..

Style: Modern 🖋 Hunt 101 (then digitized)
🖋 Black ink, then digitized for laser cutting
🪵 Wood

GIFT BASKET LABELS

I thought of this arrangement as a welcoming gift and expression of gratitude for the wedding guests. The handwritten calligraphy adds warmth to the gift basket.

..

Style: Modern 🖋 Hunt 101
🖋 Black ink
🪵 Sketch drawing paper (90 gsm)

CHAPTER

7

—

Small Gatherings And Entertaining

I've taken part in and hosted many small gatherings, sometimes with family and sometimes with friends. Each event has its own theme and story. If you find yourself hosting a party, first decide on the gathering's purpose and whom you will invite. Are they close friends or business acquaintances? Is it a birthday party, a tea tasting, a bridal shower, or something else? Once you've decided that, begin thinking about the details—the table settings, the food, the drinks, the music—and make the preparations thoughtfully.

Some arrangements, such as invitations, place cards, and food labels, call for paper to be used, These places are where you can show off your calligraphy skills. If the party is a casual gathering of close friends, use handmade paper with an easygoing modern style. On the other hand, a formal full-course dinner calls for high quality paper, possibly Italian, and a Classic script.

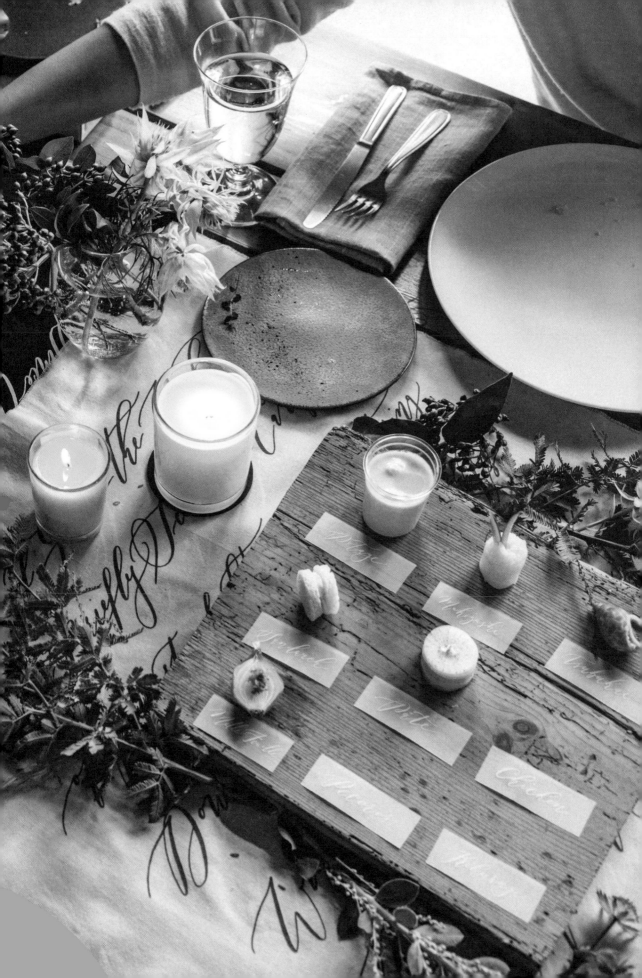

FABRIC SIGN

The fabric sign was made just for this day. I digitized my handwritten calligraphy (page 116) and had it silkscreen-printed onto linen.

Style: Modern ✒ Hunt 101
🖊 Black ink, then digitized for silkscreen printing with dark gray ink
🧵 Linen fabric

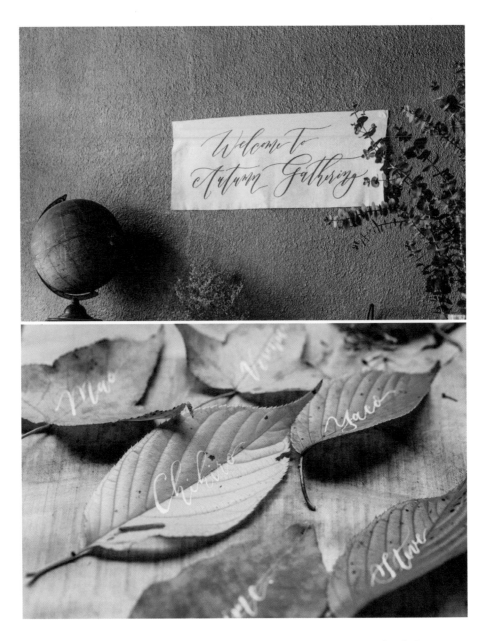

LEAF PLACE CARDS

Red and yellow leaves were a perfect fit for an autumn forest theme. The white ink provides a lovely contrast.

Style: Modern ✒ Hunt 101
🖊 White ink
🧵 Autumn leaves

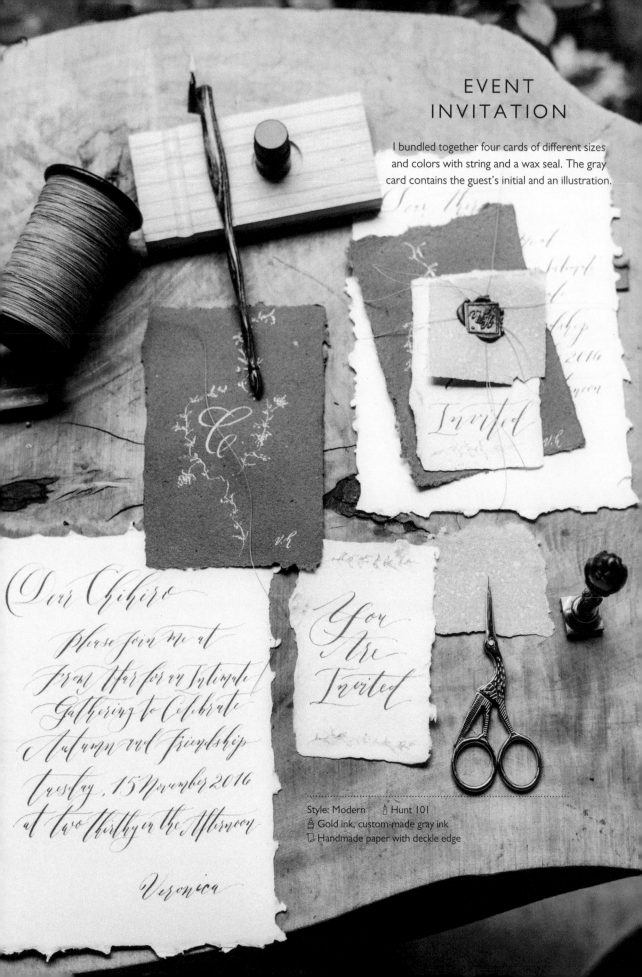

EVENT
INVITATION

I bundled together four cards of different sizes and colors with string and a wax seal. The gray card contains the guest's initial and an illustration.

Style: Modern ✒ Hunt 101
🖋 Gold ink, custom-made gray ink
📄 Handmade paper with deckle edge

VEGETABLE LABELING SCROLL

A label can make an unfamiliar vegetable familiar. On its own, the label can simply be an artful decoration; if you write a guest's name on it, it can be a place card.

Style: Modern 🖋 Hunt 101 🖊 Black ink
🗒 Sketch paper (90 gsm)

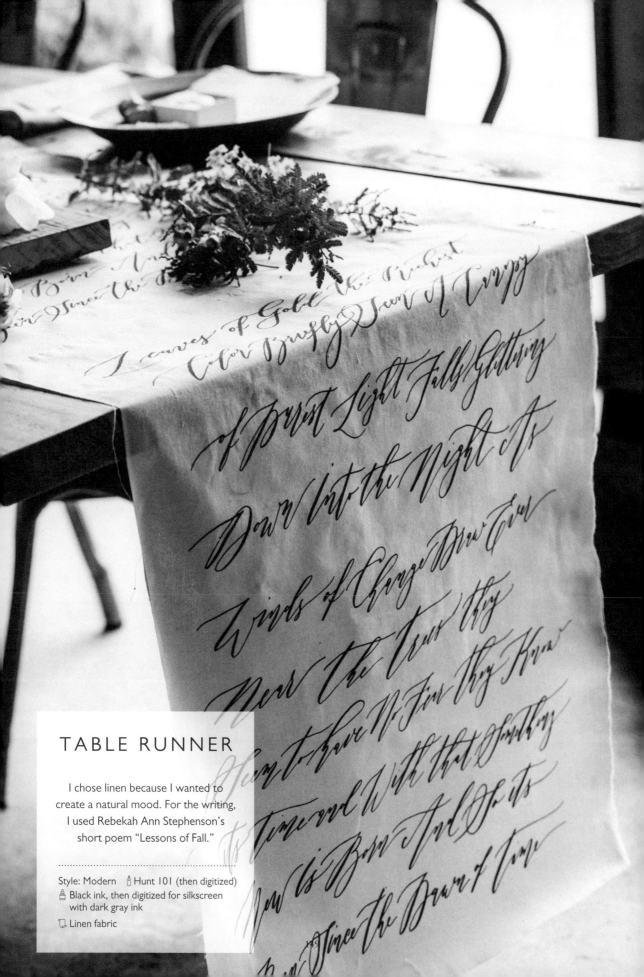

TABLE RUNNER

I chose linen because I wanted to create a natural mood. For the writing, I used Rebekah Ann Stephenson's short poem "Lessons of Fall."

..

Style: Modern 🖊 Hunt 101 (then digitized)
🏺 Black ink, then digitized for silkscreen with dark gray ink

🧵 Linen fabric

A GATHERING WITH FRIENDS

For a long time, I'd wanted to have a get-together in the autumn when the leaves turned. In Japan, it seems as if all of nature takes on a radiant beauty before preparing for winter—a perfect time to come together with friends in celebration of the forests' bounties.

I invited three friends from Kyoto who agreed to collaborate with me—Hajime, Chihiro, and Yaco. Chihiro's cooking has always impressed me; anything she touches, from the ingredients to the table, is magically transformed into something wonderful. Yaco spares no detail when it comes to making sweets! Everything she makes is like a little treasure, reminding me of precious jewels and rare gemstones. It's almost a shame to eat them. Hajime has wonderful taste. Ever since I introduced the world of calligraphy to him, he has never failed to impress me with his elegant delicate style. It's like we are on the same wavelength. Everything came together with laughter and delicious food. I'm so thankful for that day!

A gathering with friends, with whom you all can be yourselves, offers the chance to share the fun and excitement of making the preparations together as a group. Discover each of your friends' talents, and you can work together to create a beautiful gathering. Decorate food with calligraphy labels as I did with Chihiro's food; write a beautiful menu for the food you will eat; and decorate a runner for desserts such as Yaco's cookies (see page 155).

When organizing a get-together, consider the ambiance that you wish to create. I rented a space with a rustic feel and vintage furniture, but you can also borrow or rent furniture to create the perfect style. Consider a floral arrangement to perfectly capture the mood and concept; speak to local florists for ideas and suggestions. It's such a thrill to see everyone's individual talents join together to prepare a shared table.

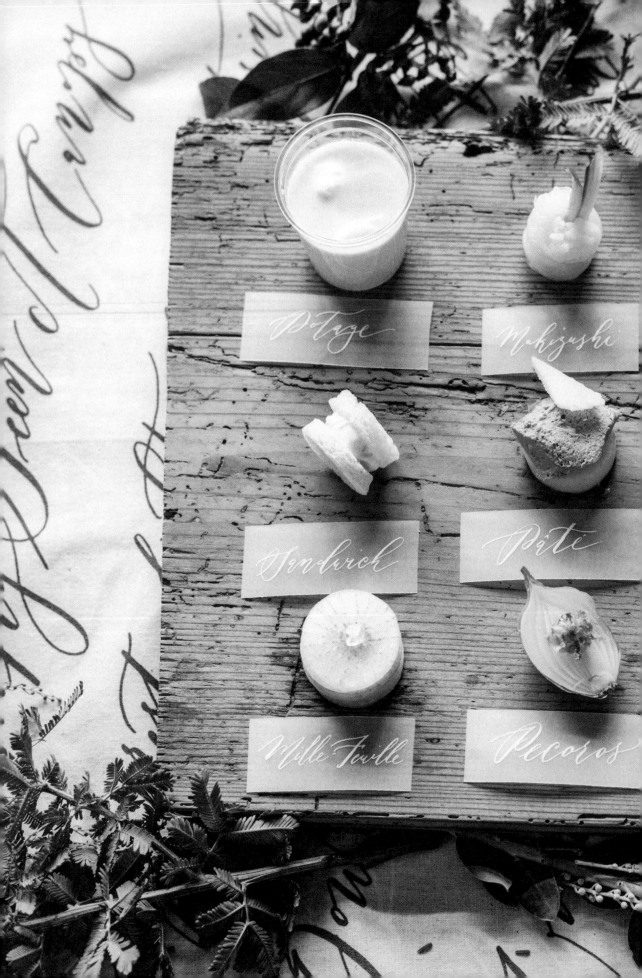

Potage

Makizushi

Sandwich

Pâté

Mille Feuille

Pecoros

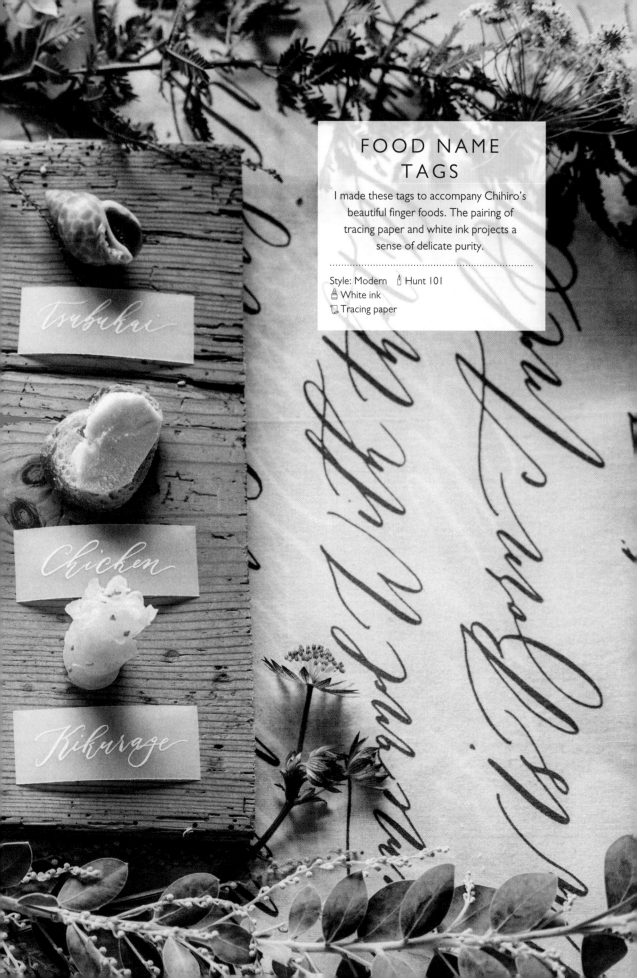

FOOD NAME TAGS

I made these tags to accompany Chihiro's beautiful finger foods. The pairing of tracing paper and white ink projects a sense of delicate purity.

Style: Modern Hunt 101
White ink
Tracing paper

Tsubukai

Chichen

Kikurage

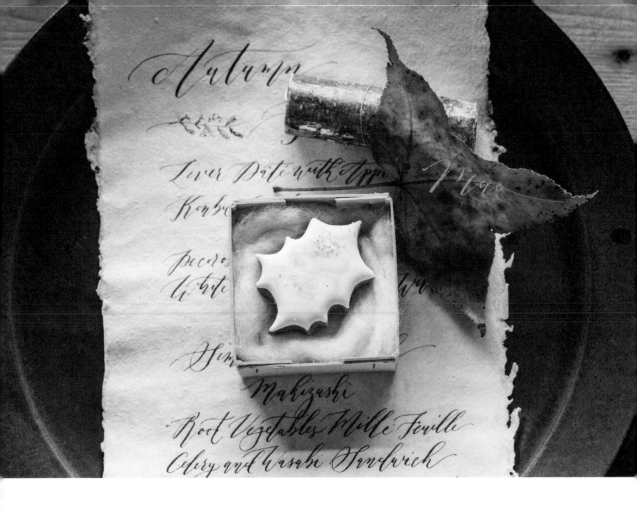

MENU

Yaco's cookie, placed upon the menu, is like a treasure found in the forest. The red leaf's quiet presence inspires talk of autumn's beauty.

...

Style: Modern 🖋 Hunt 101
🖋 Black ink
📄 Handmade paper with deckle edge

The black table runner matches with Mao's tart and this chic plate from the café.

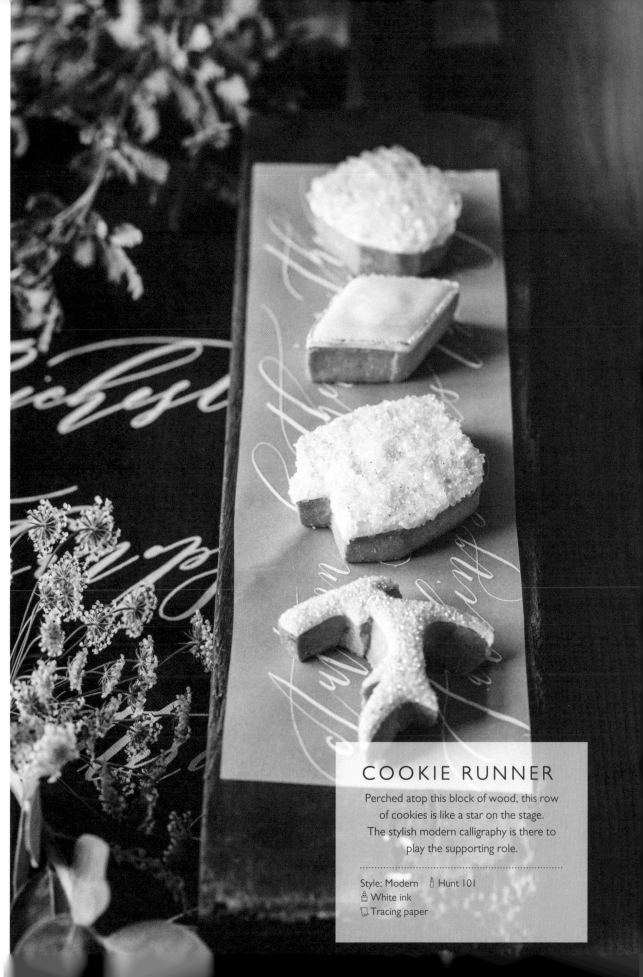

COOKIE RUNNER

Perched atop this block of wood, this row
of cookies is like a star on the stage.
The stylish modern calligraphy is there to
play the supporting role.

..

Style: Modern ✒ Hunt 101
🍶 White ink
📄 Tracing paper

Q & A

I receive all kinds of questions from people participating in my workshop. Here are some of the more common ones, ranging from questions on technique to potential uses of calligraphy.

Q.1 I'm a beginner. What kind of exercises should I start with?

As a warm-up, start every session by practicing the basic strokes for about ten minutes. This is how you will learn how to move your hand and your arm. Then, choose any letters or words you like, and write them while paying careful attention to the shapes of your letters and spaces between them. Another way to practice is to place thin paper on top of calligraphy that you like and trace over the writing.

Q.2 What do I do if my ink leaves blots on the paper?

Some inks and papers work better together than others. I always test ink with a small scrap of the paper before I begin writing. If the ink blots, you can add a few drops of gum arabic and the ink will be less likely to blot. Or try using a less liquid ink, such as gouache.

Q.3 What do I do if, in the middle of my downstrokes, the ink stops flowing and the line gets interrupted?

If you find that your nib stops putting down ink onto the paper, pause your writing and put more ink into the nib. Make sure that you're filling the vent hole with ink. Without rushing, slowly continue the stroke where the line broke, and color in to join the stroke together.

Q.4 Can I trace over your samples?

Certainly. Feel free to place thin paper over the letters or words of your choice, then trace over them. It's a great way to study and learn from their balance, spacing, curves, and elegant lines.

Q.5 How can I become better at drawing flourishes?

The best way to learn flourishes is to practice the horizontal-eights, ovals and spiral strokes Your hand will begin to loosen up, and you'll be able to draw flourishes more easily.

Q.6 When should I replace my nibs?

When your nib no longer writes smoothly or begins to catch on the paper, it's time to replace it. Always use a nib that is in good working condition.

Q.7 How long will it take before my letters turn out the way I want them to?

It's crucial to master the basics—the right way to hold the pen, managing your ink, controlling your pressure, maintaining a steady angle. Begin your search for your own style only when you can readily write the alphabet or words as you've been practicing them.

Q.8 How long should I be practicing each day?

Try to practice at least thirty minutes every day. The only way to write beautifully is through practice. That being said, it shouldn't be unpleasant. When you're focusing on calligraphy, your thoughts should be freed from the stresses of busy life.

Q.9 How can I find my own script?

First, picture what kind of world you want to create, and describe it in three words. Then think of how calligraphy can express those ideas. For example, if your three words are "elegant, stylish, and grown-up," then you can write in long, flowing strokes. But if your keywords are "sweet, cheerful, and fun," then you might write with curly strokes and looping flourishes.

Q.10 What can you do with calligraphy?

Restaurants and cafés need menus, packaging, and posters. Weddings need invitations. I love calligraphy because it can be used for so many different things.

New York

An Imprint of Sterling Publishing Co., Inc.
1166 Avenue of the Americas
New York, NY 10036

LARK and the distinctive Lark Crafts logo are registered trademarks of Sterling Publishing Co., Inc.

English translation © 2018 Elwin Street Productions Limited

Published originally under the title:
CALLIGRAPHY STYLING by Veronica Halim
Copyright © Veronica Halim 2017
All rights reserved.
Original Japanese edition published by SHUFUNOTOMO CO., LTD.

This English language edition is published by arrangement with SHUFUNOTOMO CO., LTD., Tokyo
c/o Tuttle-Mori Agency, Inc., Tokyo.

Any trademarks are the property of their respective owners, are used for editorial purposes only, and the publisher makes no claim of ownership and shall acquire no right, title, or interest in such trademarks by virtue of this publication.

ISBN 978-1-4547-1078-3

Distributed in Canada by Sterling Publishing Co., Inc.
c/o Canadian Manda Group, 664 Annette Street
Toronto, Ontario, Canada M6S 2C8

For information about custom editions, special sales, and premium and corporate purchases, please contact Sterling Special Sales at 800-805-5489 or specialsales@sterlingpublishing.com.

Manufactured in China

2 4 6 8 10 9 7 5 3 1

sterlingpublishing.com
larkcrafts.com

Translation by Nathan Collins
Design by Ryo Yoshimura, Kaho Magara (Yoshi-des Design Studio)
Photography by Studio June Styling and Photography (1–5, 7, 14, 16–18, 20–21, 36–71, 76–83, 96–97, 100–143, back cover); Shuhei Yoshida (6, 8–9); Kazuyuki Mitomi, DNP Media Art (22–23); Nao Shimizu (84–99, 144–159, front cover and flap); Erich McVey (72–75, back cover bottom right); Tetsuro Tsuchiya (12–13, 15); Eri Tanabe (19)

3 1333 04773 7778